IMAGES
of America

GREENWICH

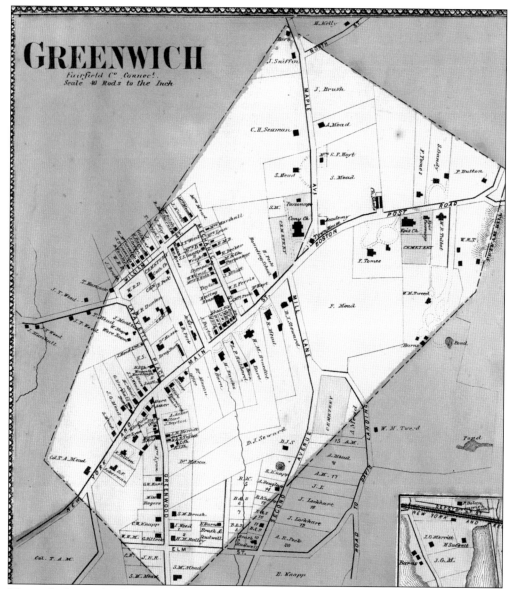

This is the borough of Greenwich as it appeared in the Beers Atlas of 1867. Although the map is drawn with minute attention to detail and shows the various homes and businesses of the time, the reader will notice one unfortunate error in the misnaming of Greenwich Avenue as Greenwood Avenue. Many of the streets of downtown Greenwich had not yet been laid out, and those that existed sometimes petered out into open fields. The borough was the local form of governance from 1854 until it merged with the town in 1931.

IMAGES of America
GREENWICH

William J. Clark

Copyright © 2002 by William J. Clark
ISBN 978-0-7385-1049-1

Published by Arcadia Publishing
Charleston, South Carolina

Printed in the United States of America

Library of Congress Catalog Card Number: 2002105017

For all general information contact Arcadia Publishing at:
Telephone 843-853-2070
Fax 843-853-0044
E-mail sales@arcadiapublishing.com
For customer service and orders:
Toll-Free 1-888-313-2665

Visit us on the internet at www.arcadiapublishing.com

To Tammy

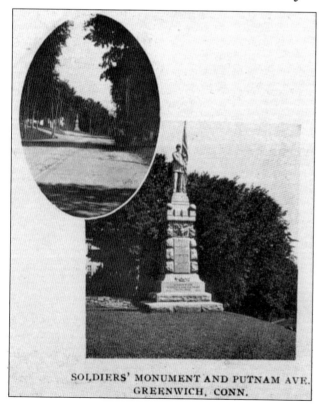

SOLDIERS' MONUMENT AND PUTNAM AVE. GREENWICH, CONN.

The Civil War memorial, erected in 1890, guards the site of the "Town House," or town hall, of the borough of Greenwich, which burned down in 1874. This 1905 view shows both the monument and the tree-lined approach to it along a still unpaved Putnam Avenue (U.S. Route 1).

Contents

Acknowledgments		6
Introduction		7
1.	Downtown Greenwich	9
2.	The Schools	39
3.	The Churches	47
4.	The Inns	61
5.	The Mansions	71
6.	The Lifestyles of the Rich and Famous	87
7.	The Neighborhoods	93
8.	The Parks, Islands, and Beaches	115
9.	Whither Greenwich?	123

ACKNOWLEDGMENTS

No book such as this can be written without many helping hands. In particular I would like to thank John Roberson, Charles Barber, the Rev. William Evertsberg, and the First Presbyterian Church of Greenwich; Robert Tate, Joan Binkerd, Mary Marks, the Rev. Jeffrey Walker, and Christ Episcopal Church; Anne Rousch, Bruce and Nancy Parker, the Rev. Robert Taylor, and St. Paul's Episcopal Church; Debra Mecky, Susan Richardson, Kirsten Jensen, and the Historical Society of the Town of Greenwich; the Rev. Alfred A. Riendeau Jr. and St. Mary Church; Peter Sanders, Michelle Viesselman, and Brunswick School; Susan Kelly and the Greenwich Country Day School; Peter Machen, Victoria Allen, and the Convent of the Sacred Heart School; Terry Betteridge and Betteridge Jewelers; Rick Chiapetta and Fleet Bank; Frank Nicholson; and the late William E. Finch Jr. I would be remiss if I did not express my appreciation to Pam O'Neil and Amy Sutton of Arcadia Publishing, whose expertise helped to shepherd this book into print.

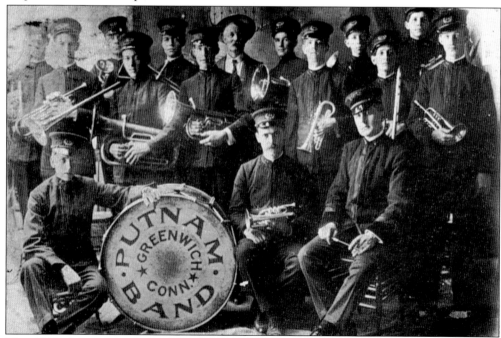

This 1910 photograph of "My Greenwich Band" is an apt emblem of people coming together on a group project. The names of this lively lot are lost in the mists of history, but the names of the equally lively lot that helped me with this book are listed with gratitude above.

INTRODUCTION

If one could travel in a time capsule to the Greenwich of 80 to 100 years ago, the first reaction would likely be, "Wow! Look how green and spacious everything is!" And the second would be, "Look at all the parking places!"

Those two comments sum up what has been a century of radical change, as Greenwich has moved from a farming to a mercantile economy, and attracted more and more newcomers through its active tourist industry, which converted many summer visitors into residents. The population of the town in 1900 was about 12,000. Today, it is more than five times that many. No wonder you cannot find a parking space on Greenwich Avenue anymore.

One purpose of this book is to give a visual record of how things changed so much during the 20th century. The reader will see historic images of the downtown area, the schools, the churches, the now vanished inns, the mansions, the clubs, and much more. Since many newcomers and visitors to Greenwich do not realize that the town is actually comprised of a number of distinct areas, some even with their own zip codes, a chapter is also devoted to the different neighborhoods. Perhaps more than any other aspect of the town a century ago, it is that neighborhood feeling that has survived, and even strengthened, as new growth and new circumstances have threatened to overwhelm the community.

One such set of new circumstances relates to the parks and beaches, now newly opened as of April 1, 2002, to all out-of-towners. For decades, Tod's Point, Great Captain's Island, Island Beach, Byram Beach, Greenwich Common, Bruce Park, Binney Park, and many other green spaces have all been operated under a residents-only policy, sanctioned by private acts of the Connecticut legislature. But the judicial branch of the state has recently taken a different view, and now Greenwich will share its incomparable natural resources with all comers.

Thus we come to another purpose of this book: to make us stop and think where the trends of the last 100 years or so will lead us in the future. Is growth good? Is the Greenwich Chamber of Commerce right to push for more and more upscale chain stores, ever higher rents, and more parking?

No one would suggest, of course, that we go back to the dirt roads and horse-and-buggy transport of 100 years ago, but perhaps we could humanize Greenwich Avenue a little by leaving our cars in already extant garages at the top and bottom of the avenue or on the side streets, and bringing back the trolleys that used to trundle up and down the hill. One trolley could start from the top and one from the bottom; they would meet in the middle and then reverse course. Shoppers could hop on and off as often as they chose, and the avenue would become a pleasant pedestrian mall. Alternatively, we could do nothing and watch as the traffic jams get worse and worse, until one might just as well be on the Cross-Bronx Expressway at rush hour.

The final chapter in the book, "Whither Greenwich?" attempts to draw some lessons from these images, many if not most of which have never been published in book form before, and ponder what they may mean for us today. The hope is that readers will come to form opinions of

their own as to where the town has been, where it is, and where it may be going. Though much is taken, much abides; it is our responsibility to preserve and honor the past even as we move into a new century that will no doubt prove just as amazing and just as full of new inventions and ideas as the one recently ended. So, please enjoy the images presented in this book, and please think about what you can do to help guide the future course of this unique and very beautiful community.

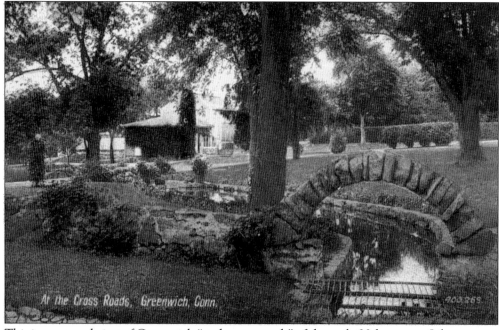

This is a postcard view of Greenwich "at the crossroads" of the early 20th century. Like so many of the other images in this book, the reader will look in vain for this scene 100 years later.

One

Downtown Greenwich

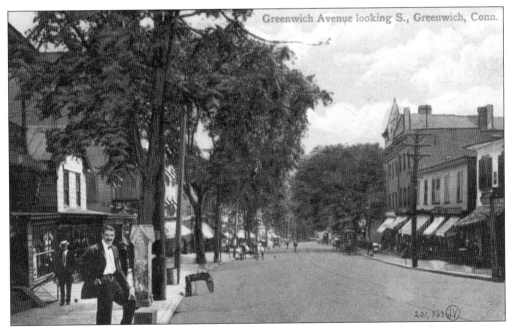

This view looking south down Greenwich Avenue dates from about 1906, as the avenue was entering a century of dramatic change. By this time the street was paved with the soft-colored bricks that gave it the nickname the "Yellow Brick Road," borrowed no doubt from L. Frank Baum's then recent book about Dorothy going off to meet the Wizard. The well-dressed men at the left and the striped shopkeepers' awnings suggest the growing prosperity of a town that was in transition from a farming to a mercantile economy.

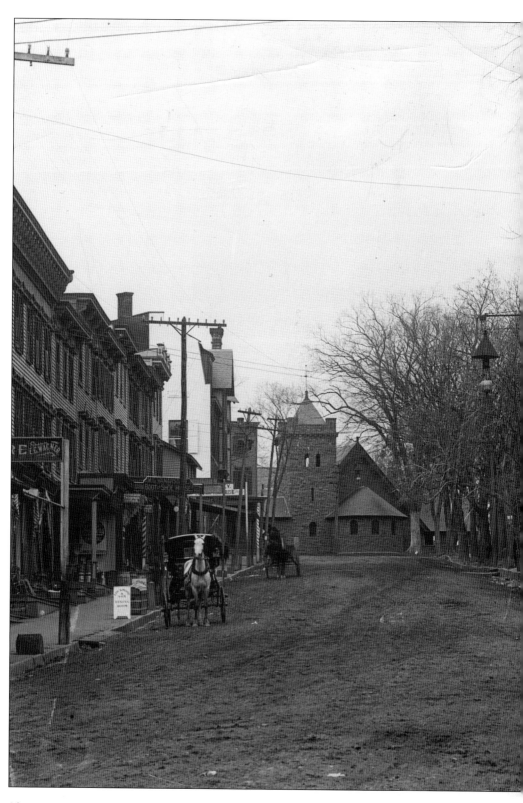

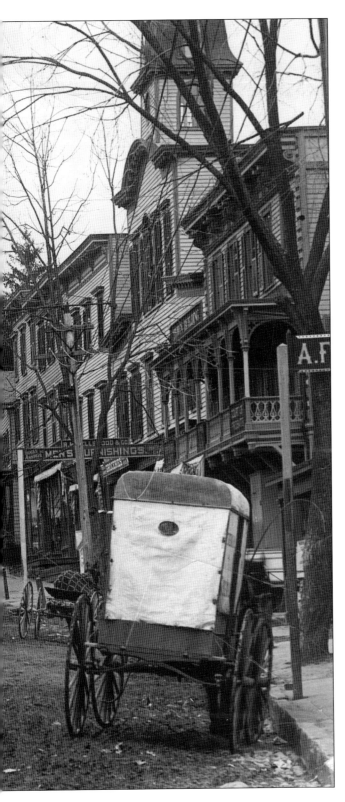

This photograph of an eerily all-but-empty Greenwich Avenue dates from the late 19th century, before the trolley tracks were laid in 1901 or the bricks in 1903. The former town hall was in the building with the porches at the right. Most vehicles of the time were one horsepower, and there was plenty of parking space on the dirt-surfaced roadway. Today, by contrast, the avenue is clogged with SUVs jockeying for ever scarcer parking places, and the feed and hardware stores have given way to upscale chain stores such as Saks and Tiffany, so that Greenwich Avenue is now known as Rodeo Drive East, or Worth Avenue North. The stately tower of the First Presbyterian Church keeps watch over this bygone scene, but it, too, has gone the way of the horse and buggy.

This view looking down from the top of Greenwich Avenue was taken in 1901 as the work of laying the trolley tracks was in full swing. Notice the large number of stately elms lining the

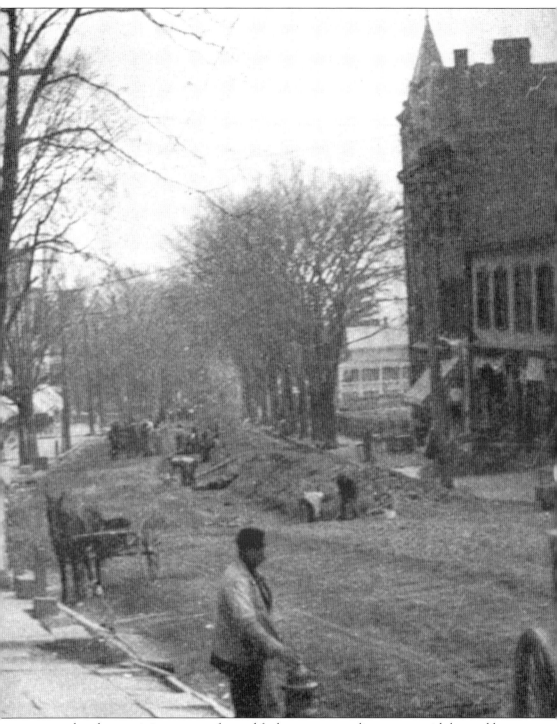

avenue; today, the remaining trees are few and far between, struggling to cope with less and less sunlight and more and more carbon monoxide.

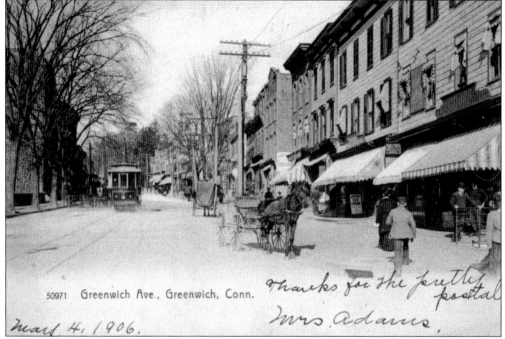

This is another view of Greenwich Avenue taken c. 1905, showing the trolley wending its way down the street. There are some who have proposed banning cars from the avenue altogether and bringing back the trolley, in order to create a pedestrian mall. The woman at the right gives one a sense of what the well-dressed shopper was wearing a century ago. Unlike today's on-the-go shoppers, she has no cell phone at her ear.

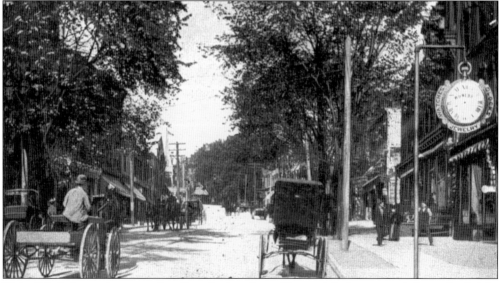

This slightly later view was taken from farther down Greenwich Avenue and shows the bright gold watch that hung outside Webb's Jewelry Store and kept the townsfolk on time. After World War II, Webb's was bought by the Betteridge family, and is one of only a tiny handful of family-owned businesses still left on the avenue. The Betteridges have recently installed a handsome new clock on the sidewalk at this same location.

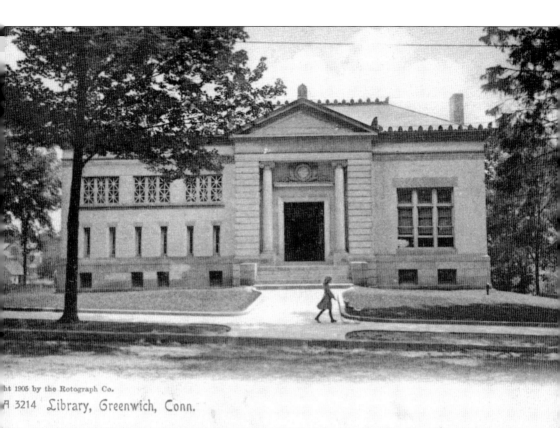

ht 1905 by the Rotograph Co.

A 3214 Library, Greenwich, Conn.

Farther down the avenue of 1905, the classic facade of the library raises the aesthetic tone of the street considerably. Notice the wide expanse of lawn and trees, and the view at left through to a home in the background. Built in 1896, the library was torn down in 1964 to make way for an F.W. Woolworth's store, for many years a staple of Greenwich shopping; the five-and-dime has now given way to an upscale Saks outlet. From free books to socks and stationery to designer scarves and mink stoles—such is the history of this part of the avenue. The trees and lawns are long since gone, as is the young girl pertly pushing her doll's carriage down the sidewalk.

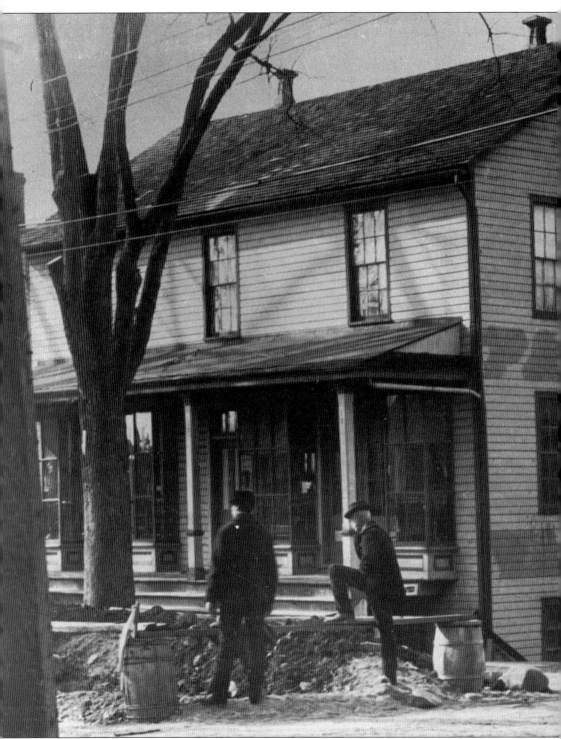

On the other side of the street from the library stood the old Greenwich Graphic building, shown here c. 1895. Off at the right stands a mansion on Field Point Road, with long-vanished open space in between. The two men appear to be earnestly discussing the events of the day,

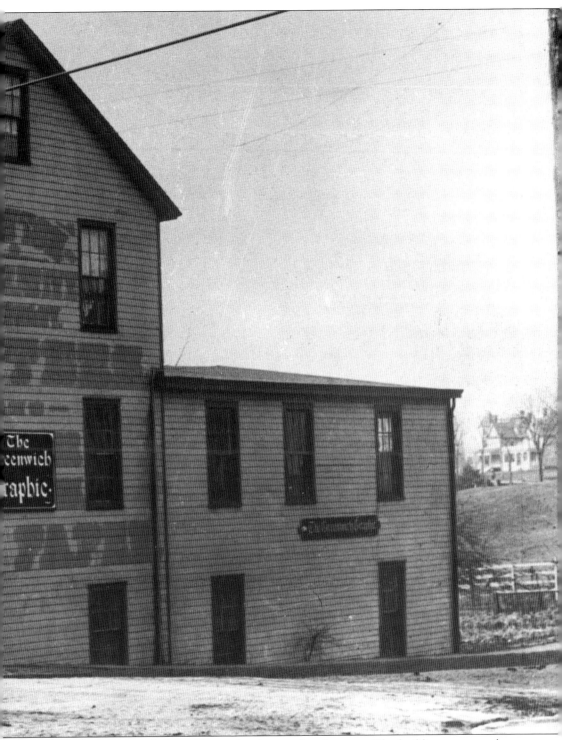

which likely did not include problems of parking or beach access. The building was torn down during World War I to make way for the new Greenwich Trust Company headquarters.

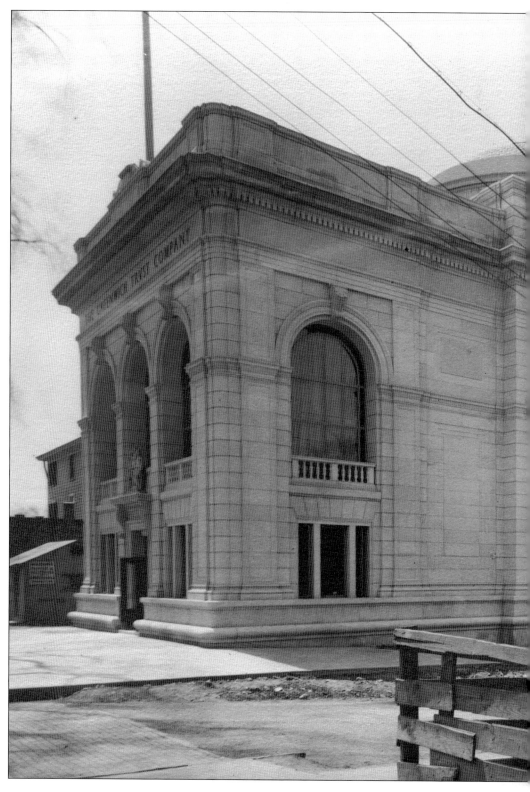

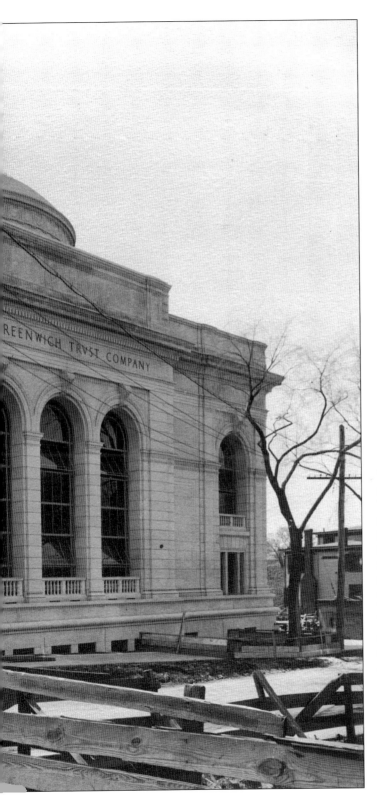

This handsome home of the erstwhile Greenwich Trust Company has replaced the old library as the architectural cynosure of the avenue. Erected in 1916–1917, it was modeled after some of the churches of Renaissance Tuscany. Its exterior is little changed today, although its name has changed many times as successive mergers have caused new signage and the addition of an ATM. The house at the right has given way to an annex housing the bank's trust department; the smaller buildings at the left have also vanished.

19

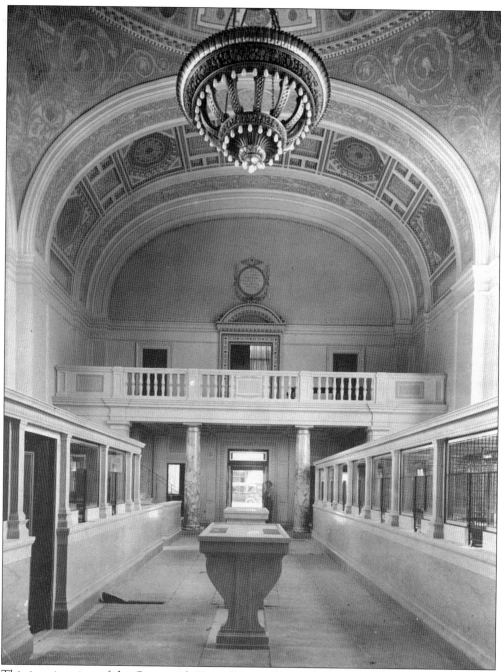

This interior view of the Greenwich Trust Company was taken about the time it first opened and shows the long-vanished tellers' cages. Built like a series of mini-fortresses, the cages were clearly designed to thwart the likes of Bonnie and Clyde, should they ever visit Greenwich. If you look closely, you will see a handsome touring car parked just outside the front door.

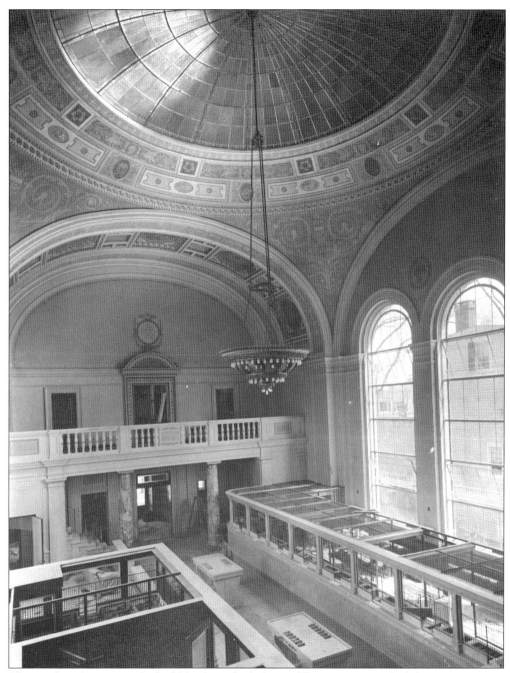

This is what the interior looked like from the balcony. The impression of solid security is quite different from today's free and open arrangement of the same space. Through the windows appears a large house just to the south of the bank; it was torn down for more office and retail space many decades ago.

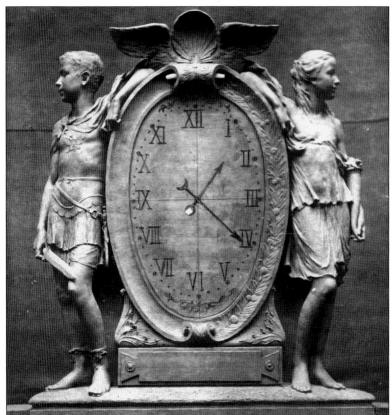

The handsome clock over the front door of the bank is supported by two Roman children and still tells passing citizens of our newer republic the time. It is interesting to see how fashions have changed over the millennia: the boy sports the ankle bracelets that are usually worn by girls in our day.

The lower part of Greenwich Avenue was still almost rustic when the new town hall was built in 1905, a gift of Robert Bruce and his sister Sarah. Notice the open fields at the right, sloping down to the gracious homes in the distance. Today, the "old" town hall is home to the senior center and a number of arts organizations, and is being refurbished inside and out for its second century of service to the community.

Once development began on lower Greenwich Avenue, it continued apace. Just a year later, in 1906, the Smith Building had been erected, currently home to Best & Company on the ground floor. While you can stand where the photographer stood and still see these same buildings, you will most certainly not see a roadway devoid of traffic. The two women crossing the street would now have to wait for Herbie, the policeman who has directed traffic at this intersection for decades, to allow them to proceed.

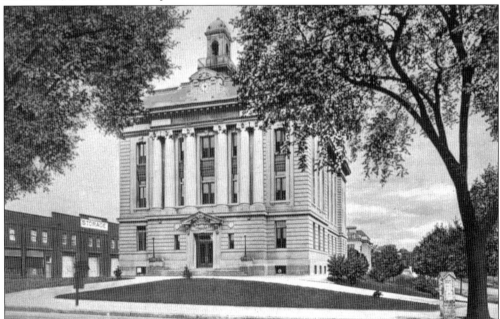

Speaking of policemen, this view of the old town hall, taken about 10 years after the one above, shows a large storage warehouse that currently serves as the police headquarters. The local constabulary feels, and the town agrees, that the department deserves a better facility; this ancient building will soon be torn down and a new one erected in its place.

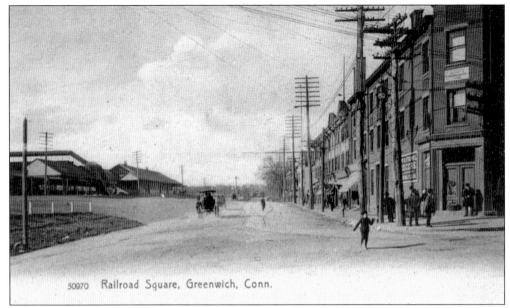

50970 Railroad Square, Greenwich, Conn.

At the bottom of Greenwich Avenue lies the railroad station. This view from 1905 shows the then newly completed station, built in 1904, which was torn down several decades ago to make room for an office block which houses the present station. The parking problem, a perennial bugbear in the Greenwich of today, obviously did not exist back then. Many of the storefronts at the right still stand, though somewhat gentrified from the boardinghouses, shops, and saloons of the period. The boy standing in the roadway and the man strolling across the street in the middle distance would not survive for long in today's heavy traffic.

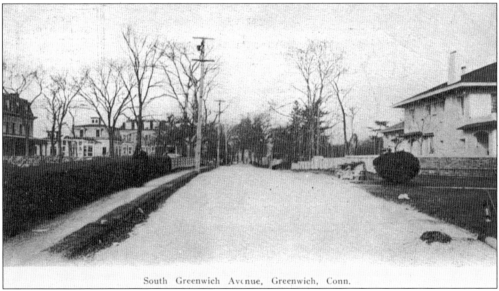

South Greenwich Avenue, Greenwich, Conn.

This is a view of what was known in 1905 as South Greenwich Avenue, today named Steamboat Road. It is a direct continuation of Greenwich Avenue, leading to a town pier and the Indian Harbor Yacht Club. Then, as now, this remains largely a residential area, although some office buildings, including the former headquarters of General Reinsurance, have been built there in recent decades.

Back at the top of Greenwich Avenue lies the Boston Post Road, better known locally as Putnam Avenue in honor of Israel Putnam, the Revolutionary War general who rode his horse down a steep ravine to escape the British. This is a 1905 view of Lafayette Place, looking north from the intersection of Greenwich and Putnam Avenues. What was then a narrow tree-lined street is now a much wider commercial thoroughfare, although the First Presbyterian Church continues to occupy the site at the left. The watering trough at this "busy" intersection was donated by Elizabeth Milbank Anderson, who also gave the funds for the old public library on Greenwich Avenue.

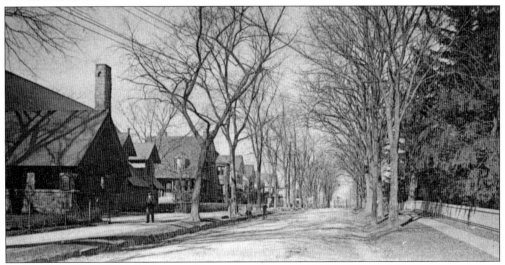

This is another view up Lafayette Place, also taken in 1905 but at a different time of year. The stately houses line the unpaved roadway, and the equally stately trees lead the eye to a long-vanished mansion at the end of the street, near where the present hospital now stands. The fence and trees at the right have given way to a large brick office building.

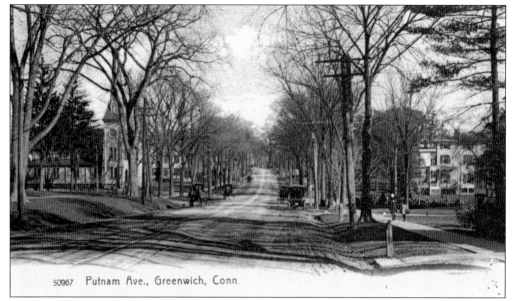

This view of Putnam Avenue shows what later became U.S. Route 1, the major highway from Maine to Florida, back when it was still a dirt road c. 1905. The stately trees, lawns, and homes are gone, although the Methodist church still remains at the corner of Church Street. Commercial office blocks and stores now line both sides of the street in the foreground.

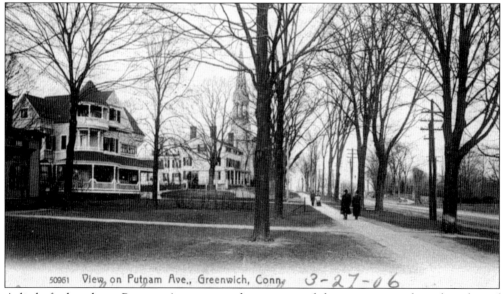

A little farther down Putnam Avenue, one has a sense of the gracious residential quality of Greenwich in 1905. Sadly, these beautiful homes have been replaced by nondescript office buildings. Only the spire of the Second Congregational Church, in the background, remains as a mute witness to this vanished scene.

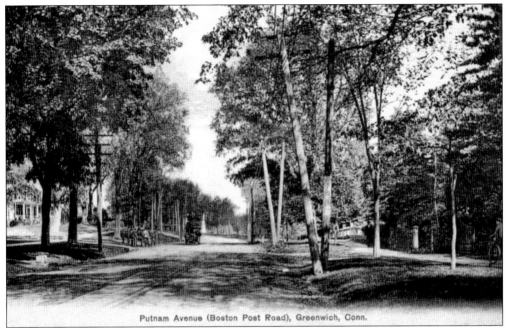

Putnam Avenue (Boston Post Road), Greenwich, Conn.

Still farther along Putnam Avenue, a group of men are watching an early automobile making its way up the street. In the background is the Civil War monument and the hillside which bursts into multicolored bloom as the crocuses appear each spring. Visible at the left is the Elms, one of the vanished inns of Greenwich. The sylvan quality of the right-hand side of the road has been replaced with yet another block of stores and offices.

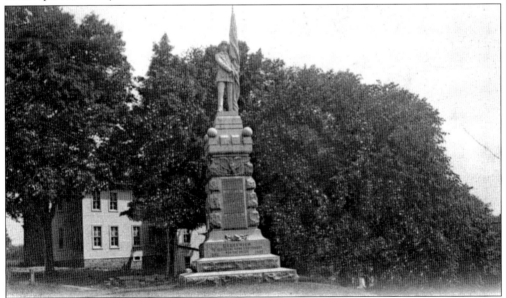

Behind the monument in this 1905 view lies the former home of Greenwich Academy, noted on the 1867 Beers map as simply "Academy." By this time the school was almost 80 years old and still coeducational. Just before World War I, it became an all-girls school and moved from its original site, at first farther up Maple Avenue. Then, in 1950, it moved even farther up, to North Maple Avenue, to more spacious and modern facilities.

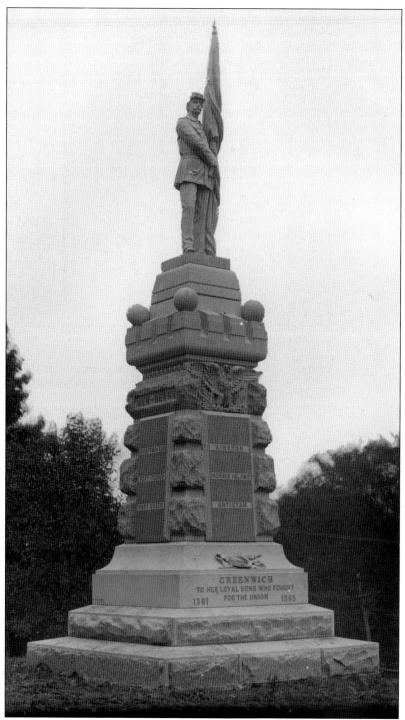

This early-20th-century photograph of the Civil War monument erected in 1890 shows a view essentially unchanged today. The old Horseneck Town House once stood on this spot, which is now a welcome green oasis helping to frame uninterrupted views of the Second Congregational Church.

Past the Civil War monument, a man drives his buggy along the rutted road towards Put's Hill, down which General Putnam rode his horse. On the right behind the trees lies the recently restored Tomes-Higgins House, for many years the rectory of Christ Church. Coming up on the left is the Putnam Cottage. The trolley tracks in the center of Putnam Avenue lead toward Cos Cob, Riverside, Old Greenwich, Stamford, and points east.

The Putnam Cottage, a tavern in Revolutionary times, was General Putnam's most probable point of departure for his famous daredevil ride. Today, it serves as the headquarters of the local chapter of the Daughters of the American Revolution (DAR). The house itself has been retro-remodeled to look as it did at the time of the Revolution; thus, the porch and the window shutters are no longer there, nor are the two cannons in front.

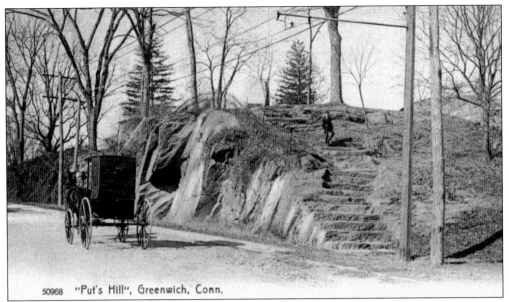

Here are the stone steps of Put's Hill as they looked in 1905. A boy is making his way down them rather gingerly. One wonders how General Putnam made it down the nearby ravine without breaking his horse's legs, or his own neck. Today, cars race up and down this hill, and the fellow in the buggy would be quickly flattened by the unending stream of SUVs.

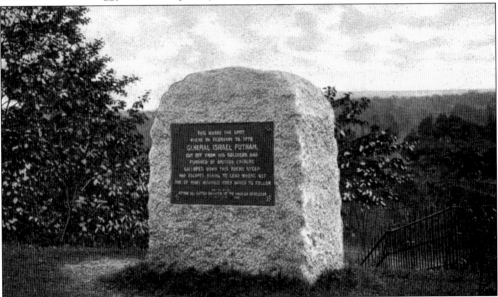

At the top of Put's Hill stands this marker erected in 1900 by the local DAR chapter. As shown in this 1907 view, the text reads: "This marks the spot where on February 26, 1779 General Israel Putnam, cut off from his soldiers and pursued by British cavalry, galloped down this rocky steep and escaped, daring to lead where not one of many hundred foes dared to follow." Putnam's ride is commemorated in the town seal, and some of his descendants continue to live in Greenwich to this day. The daredevil Putnam is also famous for the command to his men at the Battle of Breed's Hill (popularly known as the Battle of Bunker Hill): "Don't fire until you see the whites of their eyes."

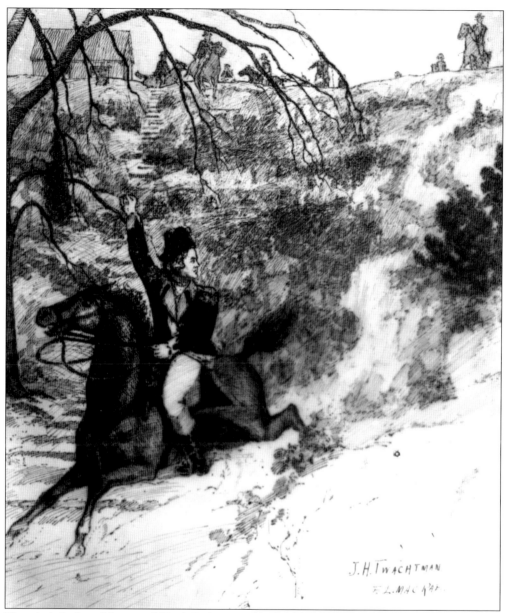

This slightly fanciful view of "Put's Ride" was sketched by John Henry Twachtman and Elmer Livingstone MacRae, two mainstays of the Cos Cob art colony in the early 20th century. General Putnam turns in the saddle to shake his fist in defiance at the enemy, while his terrified horse seems to wonder what's next. The frustrated British watch from the top of the ravine, no doubt soon to return to the tavern and discuss what they have seen over a tankard of ale. In reality, history reports that Putnam did not have time to put on his coat, but that would have spoiled the image. After the war an admiring British general gave Putnam a new hat to replace the one that was pierced by a musket ball during his escape.

Returning back toward the center of town some years later, one would find the YMCA (built in 1916) now standing opposite the Methodist church. By the late 1920s the trolley tracks had

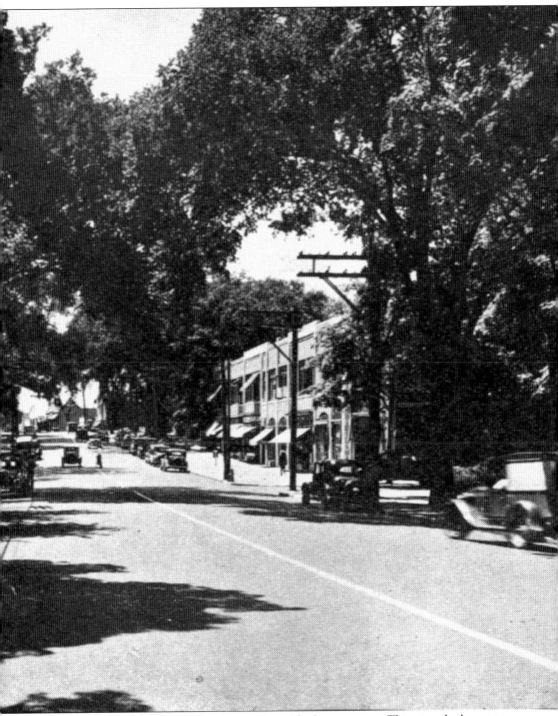

disappeared, replaced by the public's love affair with the motorcar. This view looks west on Putnam Avenue (U.S. Route 1) from the YMCA toward the First Presbyterian Church.

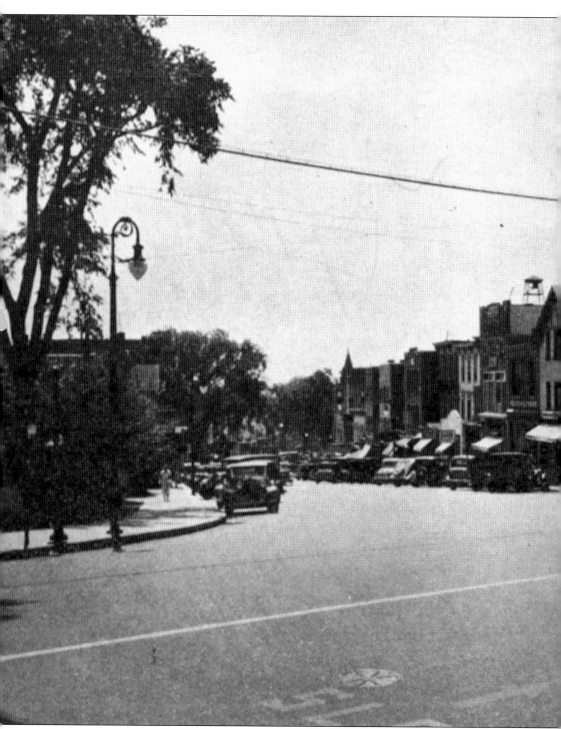

Upon arriving at the church about 70 years ago, one saw this scene. What has changed since the trolley tracks were laid down (pages 12–13)? Ah, yes—the parking problem has begun. A stoplight has been installed at this intersection, then controlled by a policeman from the booth

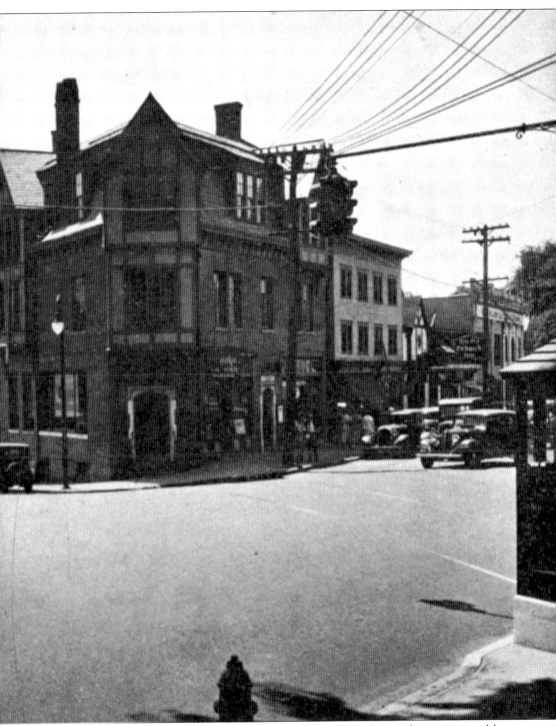
at the right, which still stands idly by today, rendered superfluous by an electronic signal box. Notice how the avenue traffic pattern was two-way instead of the one-way system of today.

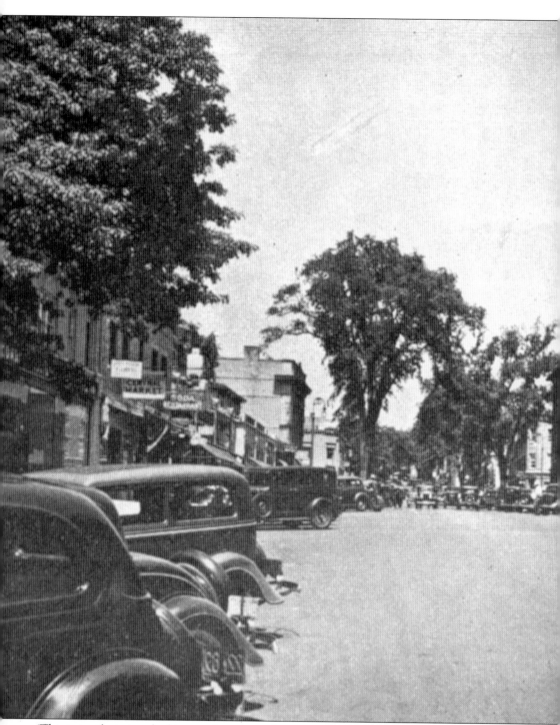

This is another view, looking up the avenue from near the town common. On both sides of the street, most of the family-owned markets, restaurants, and shops have now been replaced by national chain stores such as Saks, Baccarat, the Gap, the Limited, and Banana Republic. One

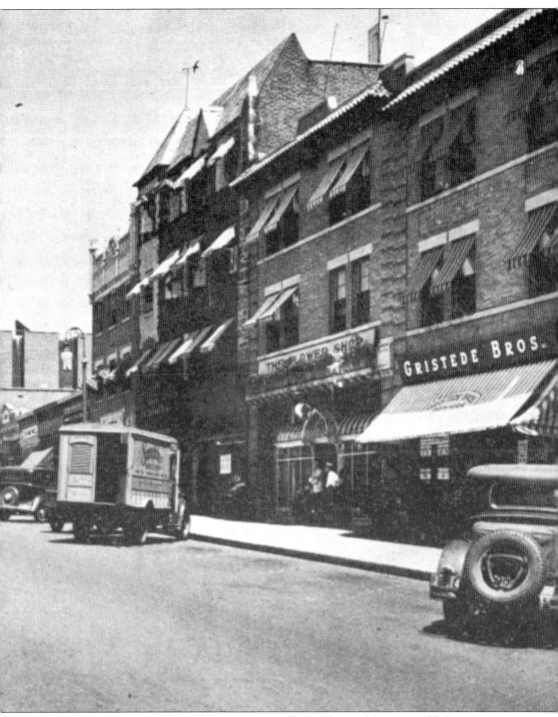

wonders what would happen if the chains were to pull up stakes and leave: would there be any locally owned businesses left to take their place, or would the storefronts remain empty?

One last image of downtown Greenwich in the old days, this shows the view from the top of Field Point Road looking out over Long Island Sound. Some of the houses at the left still survive, although the then dirt roadway has now been widened and paved. The water views are as beautiful as ever.

The old tollgate house stood west of the town center on the Boston Post Road, where travelers between New York and Boston would pay for the privilege of using the road through Greenwich. This time-honored custom was perpetuated into the 1980s with tollbooths on both the Merritt Parkway and the Connecticut Turnpike (Interstate 95), at which time they, too, passed into history.

Two
THE SCHOOLS

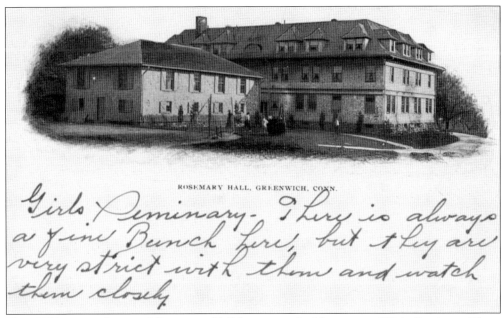

This 1902 postcard view of Rosemary Hall has a wonderful message: "Girls Seminary. There is always a fine Bunch here, but they are very strict with them and watch them closely." Rosemary Hall moved from Wallingford to Greenwich in 1900; 71 years later it moved back to Wallingford and merged with the Choate School. Its former buildings are now used by the Japanese School of Greenwich.

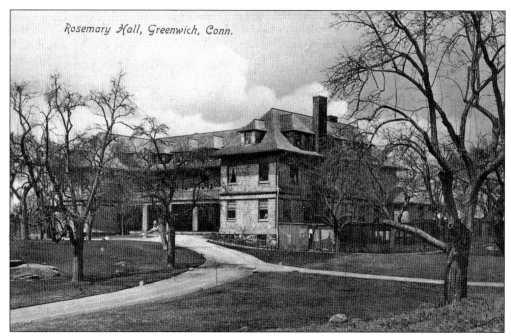

This is a slightly later view of Rosemary Hall, in 1905. Girls "seminaries," or boarding schools, were once a popular form of private education, but most of them have passed into history or, like Rosemary Hall, joined forces with a formerly all-male boarding school.

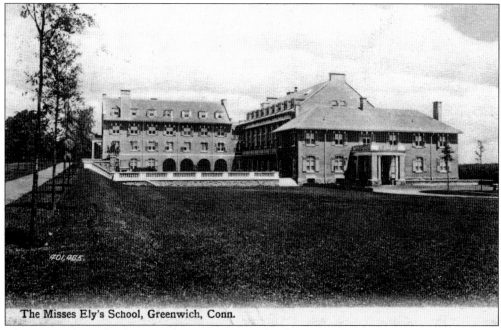

The Misses Ely's School on North Street was another long-vanished seminary for young ladies. This view was taken in 1908, the year the school moved to Greenwich. "This is a good picture of the school but it does not show half of the beautiful grounds," according to the sender of the postcard. The school burned down in 1926 and was not rebuilt.

This is how Greenwich Academy looked in 1908 at its old location on Putnam Avenue near the Second Congregational Church. The school has since moved about half a mile up North Maple Street to a much nicer physical plant, with none of the look of an orphanage about it. Founded in 1826, Greenwich Academy is the oldest girls' school (though originally coeducational) in the state of Connecticut, and remains one of the best.

Brunswick School's Maher Avenue campus adjoins that of Greenwich Academy, allowing for coordination between their respective student bodies. This image shows the Octagon House on Milbank Avenue, where the school was founded in two rented rooms in 1902. Initially there were fourteen students and two teachers, one of whom was the headmaster.

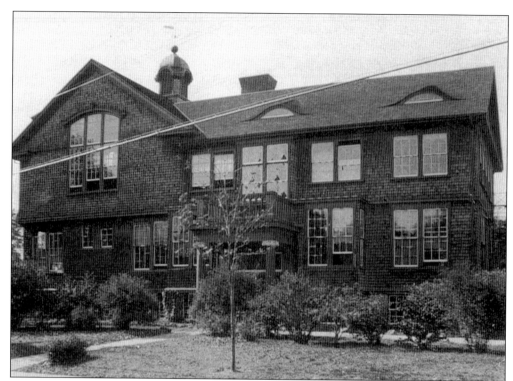

In 1906, the school moved to Maher Avenue and this new facility. It burned down in 1933, but the trustees and parents raised funds and bought debentures to finance the rebuilding of a brick structure on the original foundations; this is still used today to house the administrative offices. In the meantime the upper school met in the parish house of the nearby First Presbyterian Church.

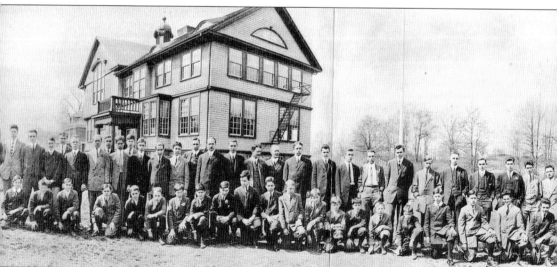

By 1912, the enrollment of the school was approaching 100, but all the students could still fit in one building. Over the years, the school has grown to its present size of about 800 boys, nearly half of whom now come from outside Greenwich. A large new campus has recently been constructed on King Street to house the middle school.

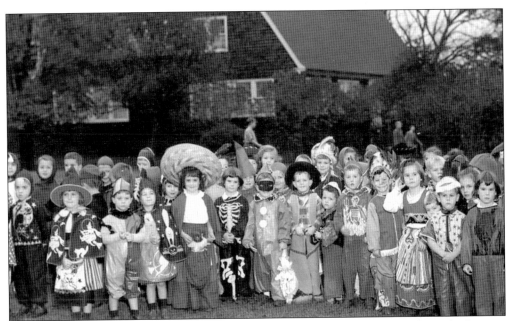

Founded with 45 students and 10 faculty in a former barn in 1926, the Greenwich Country Day School now enjoys a beautiful 75-acre campus not far from the center of town. GCDS, as it is known locally, is the alma mater of generations of budding Greenwich scholars, notably including former president George Herbert Walker Bush. This photograph shows a Halloween parade at the school in its early years, with the refurbished barn in the background.

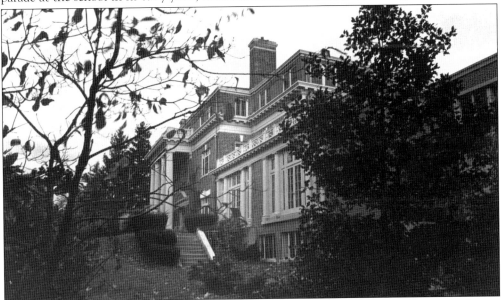

The Convent of the Sacred Heart School enjoys a beautiful hilltop setting, which was originally an estate named Overlook Farm; the views are as extensive as the name implies. The main house, designed by Carrère & Hastings, was built in 1908 and is still used as the school's administration center; now, there are many additional buildings comprising the all-girls school's large campus. Founded in New York City in 1848, Sacred Heart moved to Greenwich after World War II to this, its fifth and presumably final home.

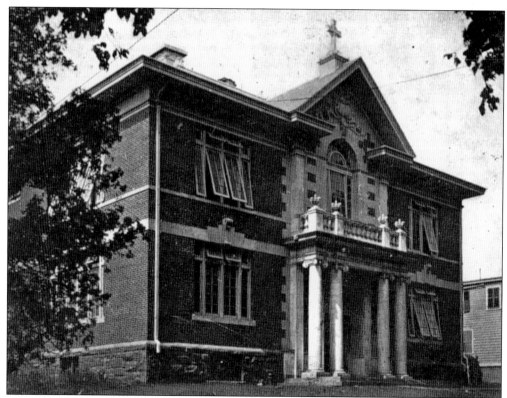

St. Mary's Parochial School was built in 1901 and stood on Greenwich Avenue for many years until it was demolished in the 1980s to make way for a large office building. This view dates from 1904 and shows how the large windows were hinged at the top, perhaps to keep out as much of the traffic noise as possible.

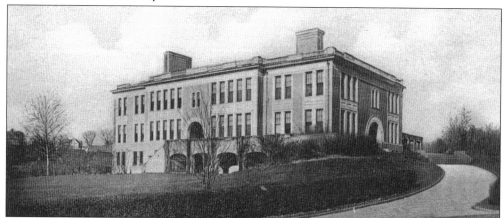

Farther down Greenwich Avenue stood the high school, built in 1892 as a gift to the town from Henry O. Havemeyer, the "Sugar King." Commodore E.C. Benedict, worried that he might not be able to send signals from his home on what is now Benedict Place to his yacht at Indian Harbor, paid a substantial sum to lower the building's roofline and to compensate the town for the gymnasium that had been planned for the top story. The building still looks much the same as it did in this 1905 view, but it is now home to the Board of Education and serves as the administrative headquarters of the Greenwich public school system.

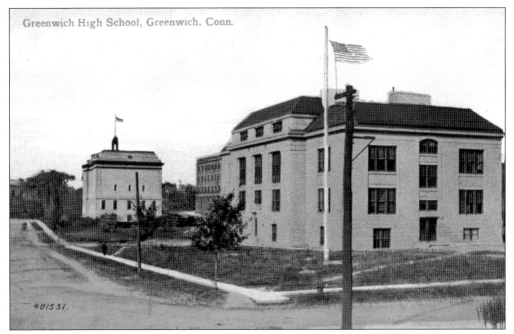

As the town grew, a new high school was needed and it was built in 1906 only a block or so away from the earlier one. This 1908 view shows the older school at the far left, and the recently built (1905) town hall in between. Later, this building was known as the Mason Street School and, today, it provides housing for lower-income town residents.

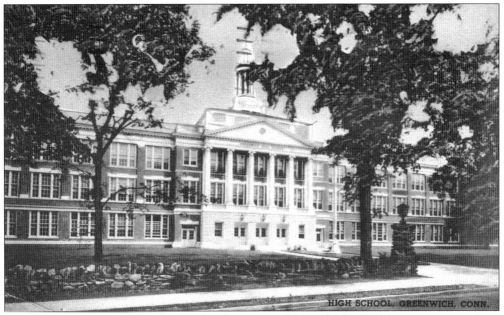

By the 1920s, yet another high school was needed, and this building was erected on Field Point Road in 1925–1926. It served until 1970, when a much larger facility was built at the bottom of Put's Hill in a more spacious campus setting. This building then began a second life as the new town hall, the city fathers having by then outgrown the older building on Greenwich Avenue.

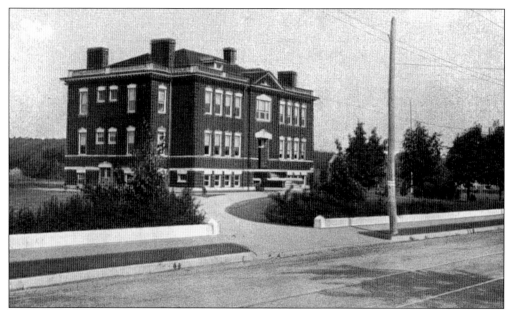

Across town stood the Sound Beach school, built to serve the needs of the eastern end of the community. It was constructed in 1902–1904 on land donated by Henry O. Havemeyer, who had also given the land for the downtown high school. Somewhat expanded since this view was taken in 1905, the building now serves as the Old Greenwich Elementary School.

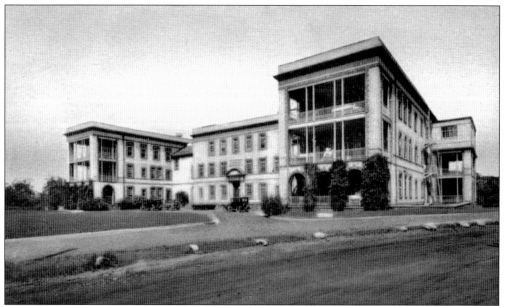

Though not a school in the strictest sense of the word, Greenwich Hospital is nonetheless now affiliated with the Yale-New Haven Hospital, and thus by extension with the larger field of medical education. This view from the 1920s shows a vintage roadster at the front door of the Benedict Building, built by the generosity of Commodore E.C. Benedict in 1915–1917; it was recently torn down to make room for a much larger and more modern building, and yet more expansion will soon follow.

Three

THE CHURCHES

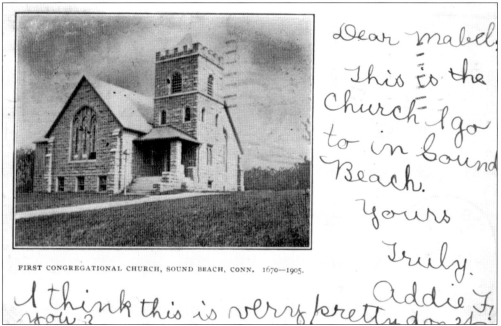

FIRST CONGREGATIONAL CHURCH, SOUND BEACH, CONN. 1670—1905.

The First Congregational Church of Sound Beach, now Old Greenwich, dates back to the days of the founding of the town. In 1895, work began on a new stone church to replace an earlier clapboard one, which burned down shortly after the new cornerstone was laid. This view shows the church as it appeared in 1905; it has been greatly enlarged since then. Not surprisingly, the open field at the right has been encroached upon by the expanding needs of the cemetery.

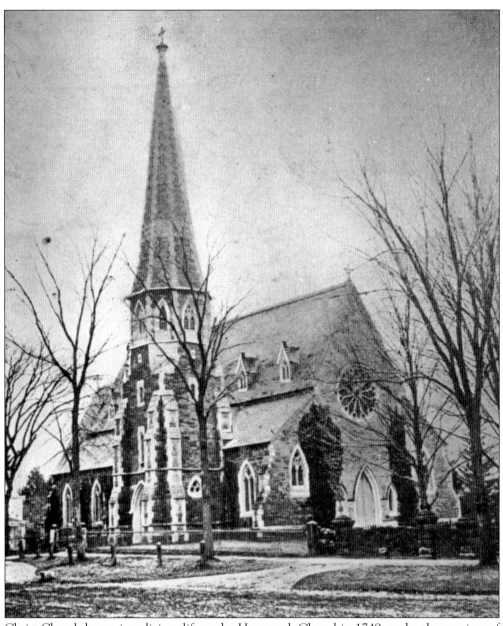

Christ Church began its religious life as the Horseneck Chapel in 1749, under the auspices of the Church of England. At the Revolution, Samuel Seabury of Connecticut was consecrated as the first bishop of the Protestant Episcopal Church by three Scottish bishops who were sympathetic to the colonials in their struggle against the British. For many years, Seabury House on Round Hill Road was a conference center for the Episcopal Church, and several of Christ Church's rectors have themselves gone on to become bishops. Recently, the Archbishop of Canterbury paid a visit here, and it is safe to say that Christ Church is one of the brightest jewels in the tiara of the worldwide Anglican Communion. This image shows the church as it appeared in 1856.

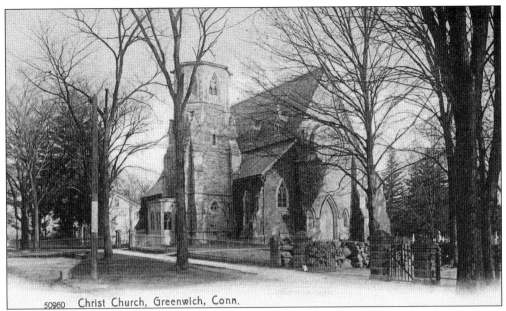

50960 Christ Church, Greenwich, Conn.

By the time this view was taken in 1905, the stone steeple had become unsafe and had been pulled down. In fact, the rector and vestry were beginning to think that the rest of the church should come down as well.

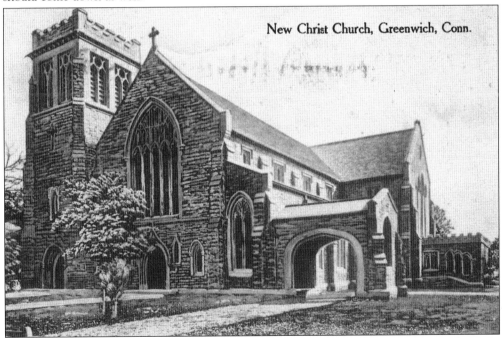

New Christ Church, Greenwich, Conn.

This is the new Christ Church, built in 1909–1910. Several of the stained glass windows are masterpieces from the studio of Louis Comfort Tiffany, and the best time to view them is when the morning or evening sun is shining through them. The luminous hues of Tiffany's glass come alive with colors otherwise unsuspected, making them a quasi-religious experience in their own right. The large chancel and balcony organs fill the church with sound, giving one the feeling of being in one of the great cathedrals of England.

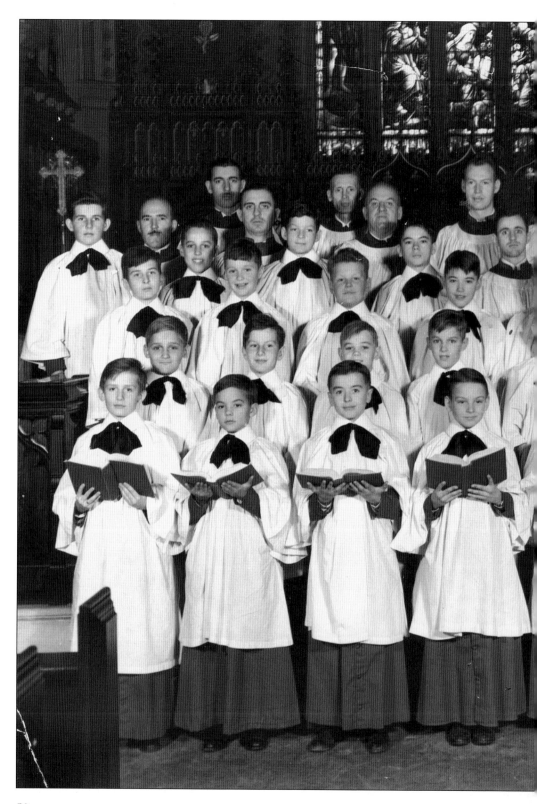

Adding to the sense of Englishness is the superb choir of men and boys, founded by Claude Means in 1934. The choir, shown here in 1938, is one of only a handful in the United States that follows the model of St. Paul's, Westminster Abbey, and King's College, Cambridge. When the choir travels abroad, it often fills in for vacationing English cathedral choirs; the highest compliment the choir receives is when people do not even notice the absence of the regular choristers. There are several other choirs at Christ Church, and its outstanding music program is a tremendous asset to the Greenwich community.

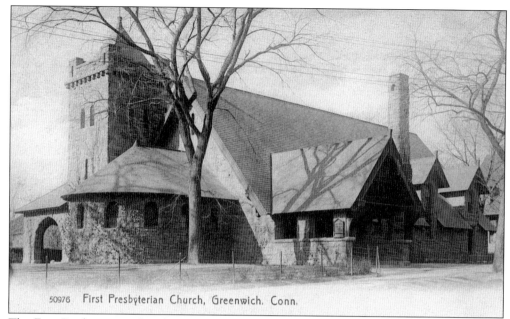

The First Presbyterian Church of Greenwich was founded on the site of a tavern and enjoys a position right at the top of Greenwich Avenue. This view from 1905 shows the old church, which has undergone numerous design changes and is in the process of yet another.

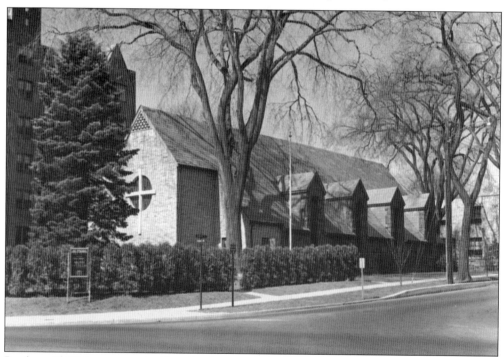

By the mid-20th century, the First Presbyterian Church had acquired a sleeker, more modern look. The tower had been taken down and a new education and office wing put up. A later expansion restored the sanctuary to an appearance more closely resembling the original church, with its high wooden-arched nave.

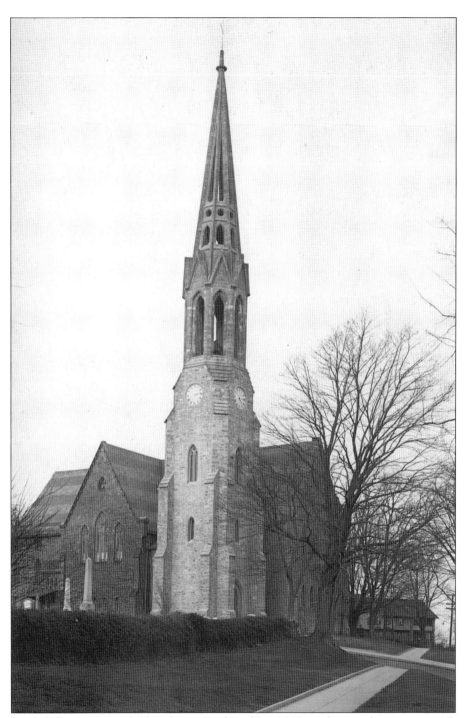

The Second Congregational Church was "gathered" in 1705, as the population center of town began to shift away from Old Greenwich towards Greenwich Avenue. The present building was erected in 1856–1857, about the same time that Christ Church was also building a new church. Its tall steeple, perched on the highest shoreline point between New York and Boston, is a well-known landmark for sailors.

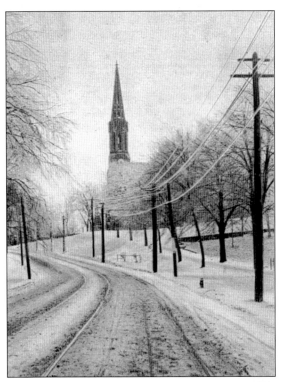

This image shows Putnam Avenue and the spire of the Second Congregational Church after a snowstorm c. 1906. Notice the ruts in the roadway and the trolley tracks; apparently people were able to get around just fine despite the lack of snowplows and salt spreaders.

The Methodist Episcopal Church dates from 1869, the height of the Victorian Gothic revival, and looked like this in 1905. It looks just about the same today, except that the little girl in her Sunday best at the lower right is unfortunately nowhere to be found. Running alongside the building at the left is Church Street, which leads to the old Fourth Ward, one of the town's historic districts that still retains much of its late-19th-century flavor. The park at the end of Church Street was originally the site of St. Mary church and its first cemetery.

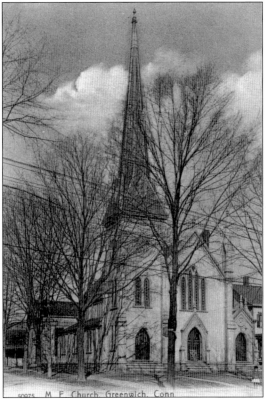

The old white wooden St. Mary Roman Catholic Church on Greenwich Avenue burned to the ground in 1900 and was replaced with this stone (and presumably more fire-resistant) building, as seen in this view from 1905, the same year the new church was dedicated. Its greensward and plantings continue to provide a welcome relief from the increasingly soulless architecture of the avenue.

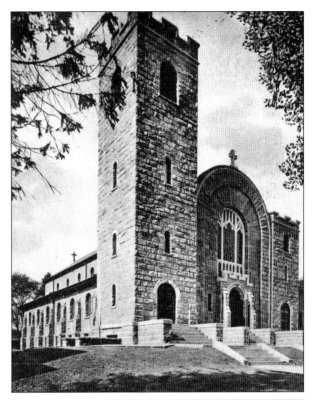

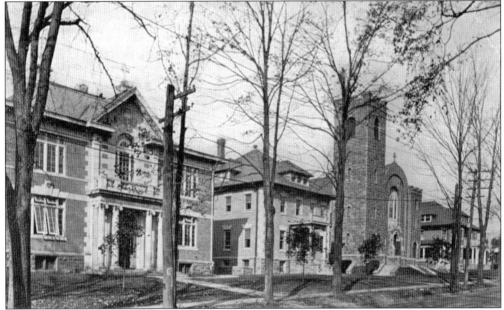

This view, taken shortly after World War I, shows the campus that St. Mary's used to enjoy along Greenwich Avenue. To the right of the church is the old rectory; to the left of the church is the old convent; to the left of that is the parochial school with its top-hinged windows. Sadly, the two latter buildings have been replaced recently by a monolithic office building with all the charm of a large brick box.

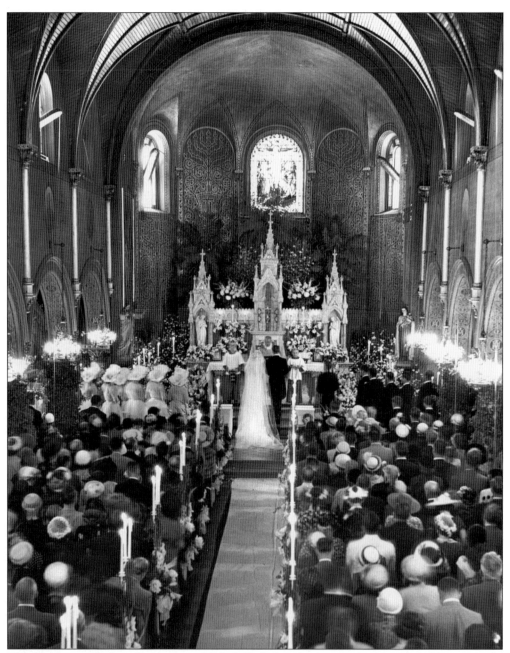

The wedding of Robert Kennedy and Ethel Skakel took place at St. Mary's. Bobby Kennedy, later the attorney general of the United States and brother to the assassinated president John F. Kennedy, was himself assassinated in 1968 while running for president. Michael Skakel, nephew by marriage to the Kennedys, was convicted in 2002 of the murder of 15-year-old Martha Moxley in Greenwich in 1975. However, at least on this day back in 1950, there seems to have been happiness in the air at this festive gathering of the Kennedy clan.

The Reverend Mr. Richard Hegerty was minister at the Diamond Hill Methodist Episcopal Church in the early years of the 20th century. His double-breasted suit has satin lapels, and his bow tie is immaculately tied in his high collar. This image, showing his eyes looking heavenward, was made into a postcard, which might seem to smack of vanity were he not a man of the cloth. The author is not aware of any other Greenwich ministers who have had postcards made of themselves and confesses he is rather glad that the Rev. Hegerty did not start a trend.

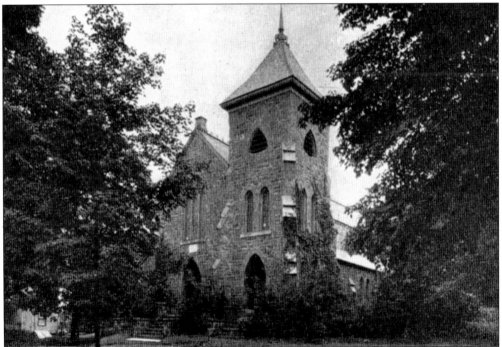

The Diamond Hill church still stands at the top of this rise in Cos Cob, much as it appeared some 70 years ago. Like several other churches in town, it has an active preschool program, which has led to the installation of stoplights at the top of the hill; these have a somewhat calming effect on the incessant flow of traffic passing by.

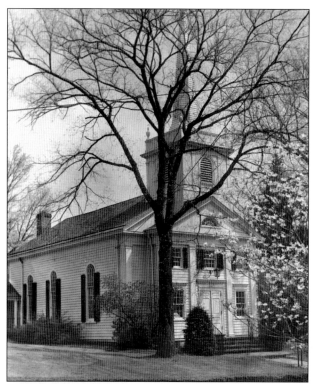

The tranquil appearance of the back-country Round Hill Church belies its somewhat turbulent recent history. The building is owned by the Methodist Church, although over the years it had become the community church for much of the Round Hill area. When the Methodist denomination reasserted its right of control in the late 1970s, a large portion of the congregation walked out and built a community church a little way down the road. It is interesting to note that this was merely the latest of several such splits in the religious history of Greenwich, as the First Presbyterian Churches of both Greenwich and Old Greenwich were founded by breakaway groups from the Second Congregational and First Congregational Churches, respectively.

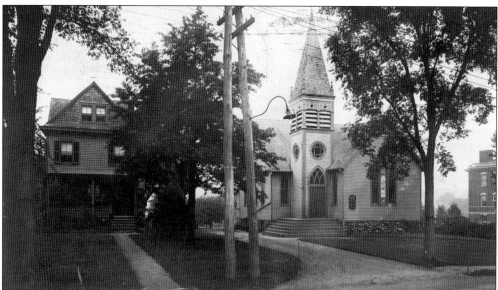

The First Presbyterian Church of Sound Beach, now Old Greenwich, was situated next to the Sound Beach High School, which can be seen at the right of this 1910 image. The house on the left was the parsonage. The church is still in use today, although not by the Presbyterians, who have moved to a larger and more modern church a few blocks away. In 1894, a disagreement over the dismissal of the minister at the First Congregational Church caused about half the congregation to leave and found this church, originally called the Pilgrim Congregational Church; in 1899, it joined the Presbyterian denomination.

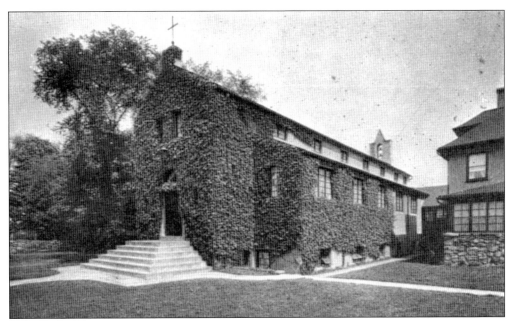

St. Catherine of Siena Roman Catholic Church was built in Riverside in 1913. This rather modest original church has now been replaced (on the other side of East Putnam Avenue) by a much larger brick edifice in the Georgian style with a tall steeple.

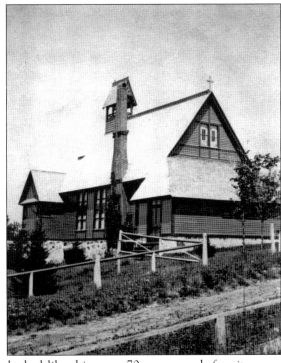

St. Paul's Episcopal Church in Riverside looked like this some 70 years ago, before its move from Chapel Lane to its present location on Riverside Avenue. In more recent times, the church parish hall has been the setting for art exhibits and dramatic productions, most notably some of the rollicking Gilbert & Sullivan operettas.

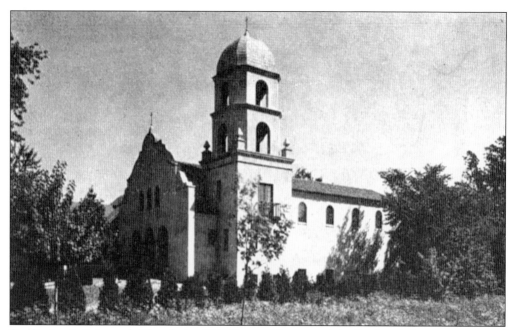

St. Saviour's Episcopal Church in Old Greenwich was originally founded as a mission of St. Paul's, Riverside. The chapel was consecrated in 1923; the full church, as seen here, was completed some 11 years later. Its Spanish architecture is a landmark for travelers going to and from the beach at Tod's Point.

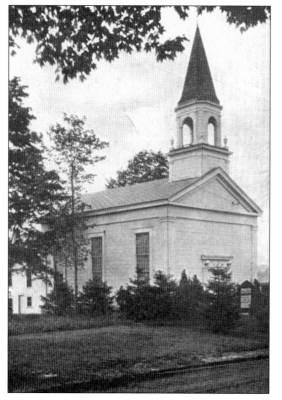

The Stanwich Congregational Church dates from 1846 and was originally a Methodist Episcopal church building. The original Stanwich church burned down, and the congregation moved here. One of the most popular back-country churches, it is in the process of building a new sanctuary nearby to accommodate its growth in membership.

Four

THE INNS

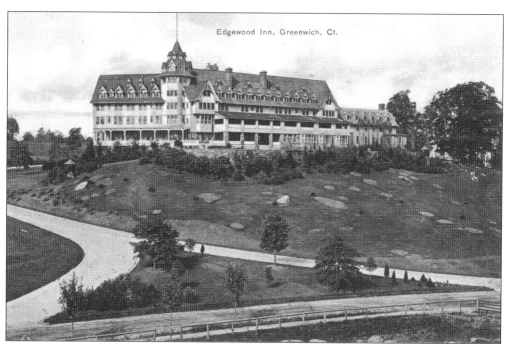

A hundred years ago, Greenwich was a popular summer resort area and people would come out from the city to spend a month or even the whole summer at one of these elegant inns. In 1905, the Edgewood Inn was perhaps the largest and finest hostelry in town. With 160 rooms in its parklike setting, it was the destination of choice for many visitors to Greenwich. After changing hands several times, it became a junior college; it was torn down in 1940, and not a trace of it remains today. Sadly, the same is true of virtually all the other great inns that graced Greenwich in the early 20th century.

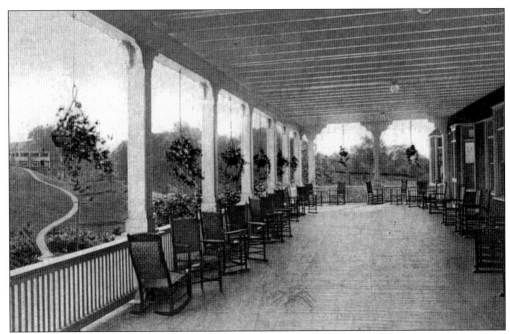

This page shows two of the public areas of the Edgewood Inn. Above is the Music Room Veranda as it appeared in 1908, with comfortable wicker chairs and hanging baskets of flowers. The slower, more gracious lifestyle of Edwardian times has vanished, along with the inn itself.

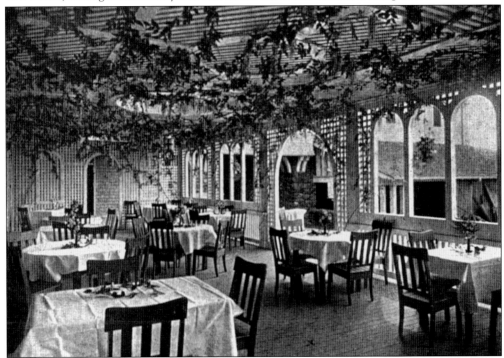

Here is Ye Colonial Tea Room, "Rest for the Tired," ready to receive visitors returning from a hard day of sightseeing. Crisp table linens and vases of fresh flowers suggest the elegance of the inn.

The Edgewood Inn also had a casino, as shown in this 1908 view. If the music room was too tame, one could come here to what was undoubtedly one of the "hot spots" for nightlife in Greenwich at the time. The tennis courts, at the right, seem underutilized; perhaps the photographer chased the players away while he set up his camera to take this picture.

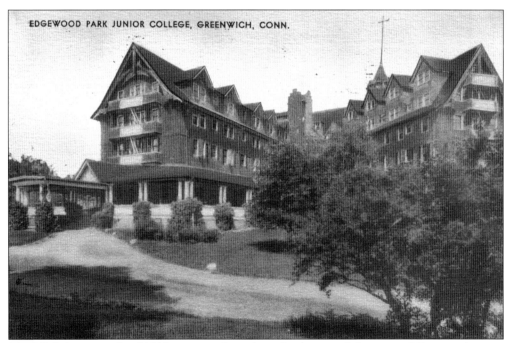

The Wall Street crash of 1929 seems to have brought the era of the inns of Greenwich to an abrupt close. By the early 1930s, the Edgewood had become a junior college. This view, taken from the back of the old inn, gives one a sense of how large it was in its heyday.

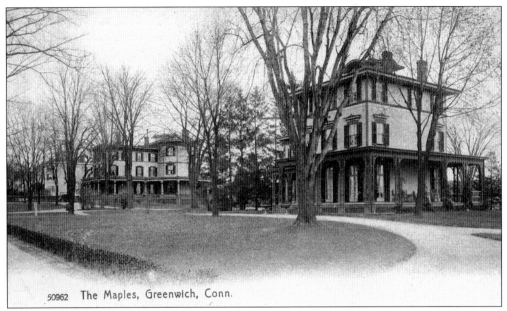

50962 The Maples, Greenwich, Conn.

The Maples was another popular hostelry. As seen in this pair of images, it grew by leaps and bounds. In 1905, it consisted of the commodious house at the center left, with stately maple trees gracing the lawns. Commodore E.C. Benedict had lived here before building his Indian Harbor mansion.

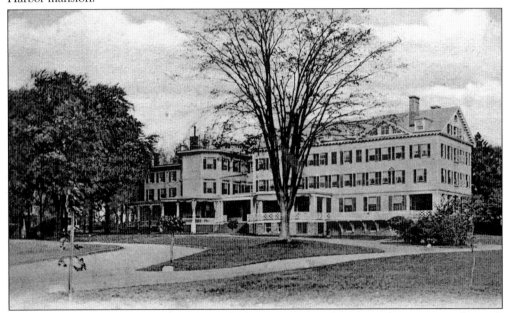

By 1908, a large new wing had been built to accommodate increasing visitor demand. The railroad made Greenwich an easily accessible tourist destination, particularly from New York City, and clearly the town made a point of welcoming the influx of visitors in those days. The Maples was demolished in 1967 to make room for the new headquarters of Chesebrough-Ponds and, today, the town is down to just one major hotel, at the eastern border with Stamford, although another one in the harbor area is scheduled to reopen soon after extensive remodeling.

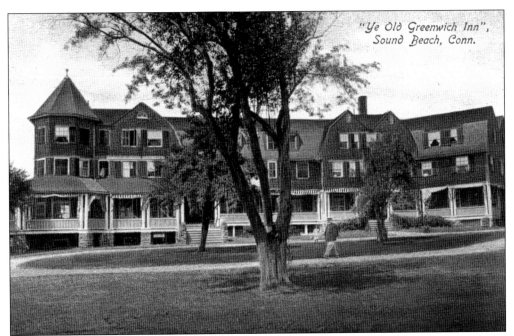

Ye Old Greenwich Inn was the largest of several hotels in Sound Beach, now known as Old Greenwich. This view dates from c. 1910 and shows a portly gentleman walking off his lunch, watched by a little girl in a pinafore, standing in the background. At this time the current town beach at Tod's Point was still in private hands but the inn, situated on Shore Road, had access to other beach property nearby. The inn burned down in 1925.

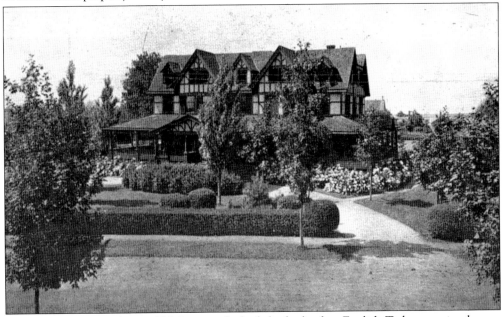

The Crossways Inn, also in Old Greenwich, had the look of an English Tudor mansion house, with neatly trimmed hedges, lawns, and flower beds. The writer of this 1905 postcard obviously enjoyed his stay there: "This is the Inn we are staying in for the month of July. It is like your own home. Delightful people."

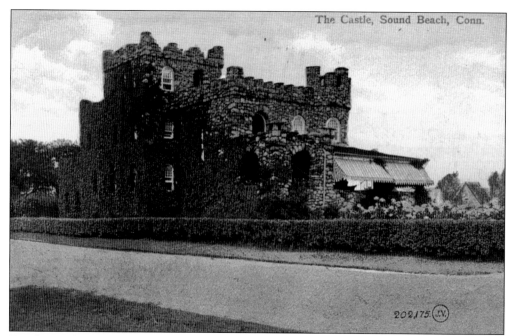

For those who wanted even more baronial treatment, the Castle in Old Greenwich was a popular place to stay. Its ivy-covered stone walls and crenelated towers, set amid hedges and flowers, are shown in this 1907 view. It later became part of the Shorehame Club.

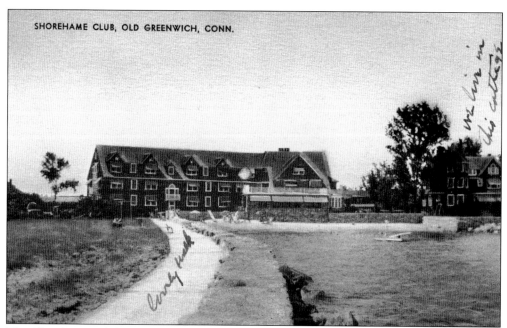

The Shorehame Club was another favorite during the 1920s and 1930s. This postcard view bears two notes: "lovely walk," on the pathway, and "we live in this cottage," above the building at the right. Once again, one has the feeling that guests were made to feel as though they were in their own home, which may help to account for the popularity of Old Greenwich as a resort area.

The Elms was a central Greenwich guesthouse a few blocks east of the Maples, though not as large. People would open their homes to paying guests in a bed-and-breakfast fashion and occasionally move into the hotel business full-time. The Elms stood at the corner of Maher Avenue and Putnam Avenue; it was torn down in 1941 and has been replaced, like most other old-time downtown inns, by an office building.

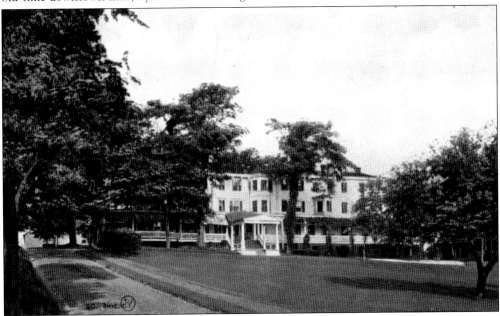

Kent House was a large hotel in the Belle Haven area of town, close to the water and to Field Point Park. This 1907 view shows its commanding position overlooking the harbor. The Belle Haven area had formerly been largely agricultural; today, it is one of only a handful of private communities in Connecticut with its own taxing authority and its own police force. Kent House was torn down in 1955 to make way for the Connecticut Turnpike (I-95).

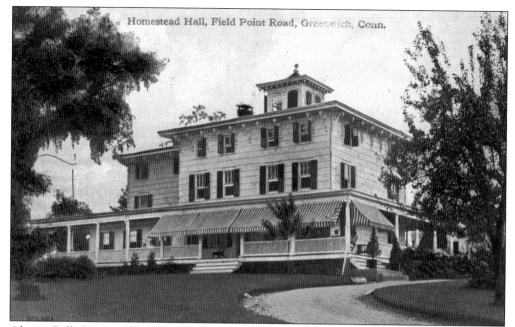

Also in Belle Haven, Homestead Hall is now known as the Homestead Inn and is one of the most elegant small hotels in the country. Its well-known restaurant is usually booked months in advance. Before its transformation into a hostelry, the building was a school during the early 20th century. One way or another, the Homestead has always been a popular destination and is outwardly little changed from this pre–World War I view.

The Lenox House graced the upper part of Greenwich Avenue and was one of the largest inns of the prewar era. It was torn down after World War I to make way for the more elegant Pickwick Arms.

The Pickwick Arms opened in 1920 and stood for over 50 years at the top of Greenwich Avenue. Its spacious lawns and flower beds were an oasis of pastoral charm, and it proudly boasted itself "New England's most beautiful family and transient hotel." Alas, it too has been torn down and replaced by a large complex of office buildings, which retains the name Pickwick Plaza.

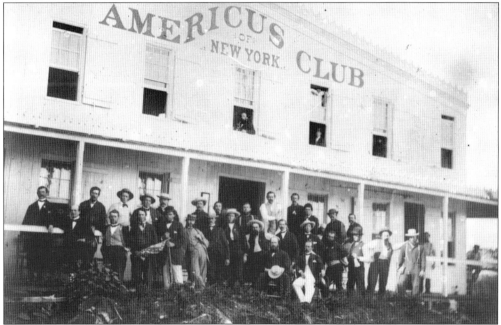

William M. Tweed, the notorious political boss who was caricatured by Thomas Nast, built his Americus Club in Greenwich in the 1860s and held lavish gatherings here. Because of his local largesse, some felt he was an asset to the community; others took a more jaundiced view of his liberal dispensing of what they felt was tainted money. You can find his house shown on the 1867 Beers map (frontispiece) directly south of Christ Church and its cemetery. Tweed died in disgrace in a New York City jail in 1878.

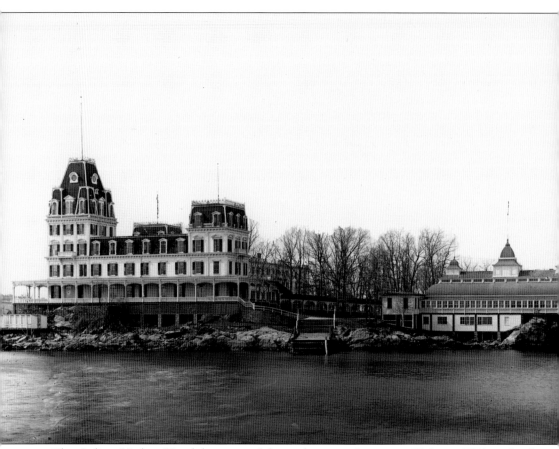

The Indian Harbor Hotel began its life as the new Americus Club in 1871 and, after Boss Tweed's departure, it became an inn open to the public. Notice the large dining hall off to the right, reached by a covered walkway from the hotel. The buildings were later bought by Commodore E.C. Benedict, who had them torn down to make way for his magnificent new home.

Five
THE MANSIONS

The great homes of Greenwich were popular subjects of postcard makers in the early years of the 20th century. Some of these handsome houses still survive; others have been razed to build new 10,000- to 20,000-square-foot homes. Perhaps the most visible of the great mansions of Greenwich, this one was built in 1895 as the residence of Commodore E.C. Benedict, a Wall Street financier, on a promontory at the mouth of Greenwich Harbor. The site had once been occupied by Boss Tweed's Americus Club, which later became one of the town's many summer hotels. This 1907 view shows the house as originally built; a later owner removed the top story. The best way to view this property is from the town ferryboat on the way to the islands.

From the late 19th century until the stock market crash of 1929 and the ensuing Great Depression, Greenwich was the town of choice for Wall Street magnates and captains of industry for building their homes. One of the most popular areas was Belle Haven, where Field Point Park was being converted from a racetrack, and earlier a farm, into choice waterfront lots. Edward Shearson built this sprawling mansion there; six chimneys may have been the local record at the time this image was taken *c.* 1908.

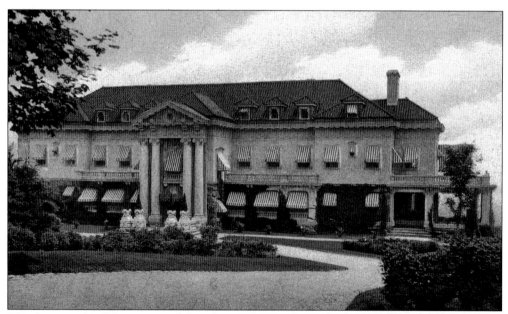

The sharp-eyed will have noticed that the top picture shows the back of Shearson's home, with steps leading down to the lawn overlooking Long Island Sound. Equally imposing is the front of the house, with its classic entrance portico. As with the back, every window has a striped awning to ward off the summer sun in those days before the advent of central air-conditioning.

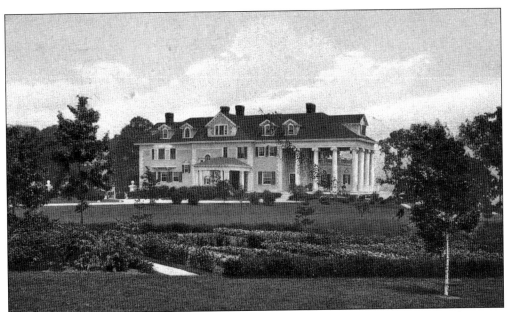

Shearson's neighbor George Dominick managed to scrape by with only four chimneys. Dominick was on the vestry at Christ Church and was one of those who helped to raise funds to build the new house of God in 1909–1910. His own house was already built, as seen in this 1908 photograph.

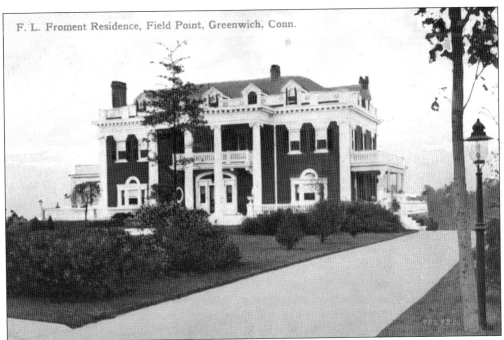

F.L. Froment preferred the classic red brick Georgian look for his "cottage," seen here in 1908. Note the gas lantern at the right; some of these still survive in the neighborhood.

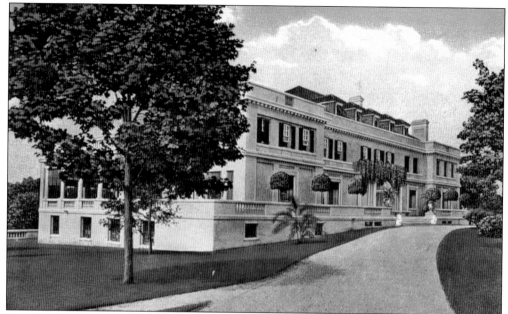

The facade of the R.A.C. Smith residence seems to stretch on forever in this pre–World War I view. Topiary, wisteria, and fronds help to soften the otherwise stern effect. Called Miralta, it was built in 1902 around the edge of the oval racecourse in Field Point Park. Smith, who founded what is now Connecticut Light and Power, bought the house in 1909.

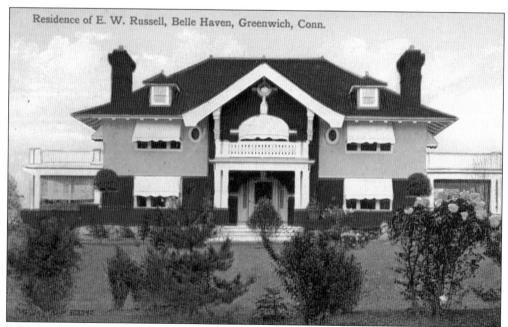

E.W. Russell's villa was built in a Mediterranean style with a red tiled roof. How he managed to heat his home with only two chimneys is a matter for speculation; clearly, though, his house was not as large as those of some of his neighbors. He, too, used topiary, flowers, and newly planted trees to landscape what, in this 1907 view, appears to be his just finished residence.

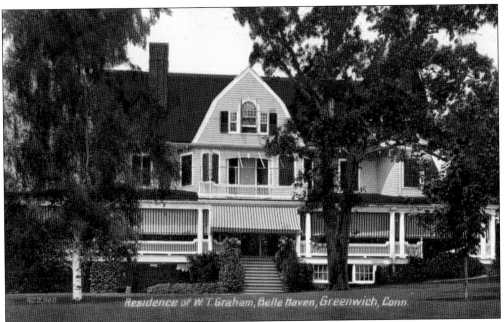

W.T. Graham's home was one of the older ones in the area at the time this picture was taken in 1907. The mature lawns, flower beds, and trees had had time to grow and flourish by then. As is still the case today, the Belle Haven area was a rich mix of architectural styles, ranging from late Victorian, like this house, to the most modern designs. In 1912, the Grahams went on the maiden voyage of the *Titanic*; they survived the disaster and were rescued by the *Carpathia*.

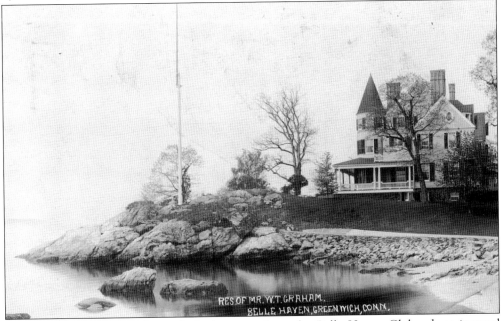

This is how the Graham house looked as seen from the Belle Haven Club, where it stood for almost 100 years. Many such homes have been razed in recent years in exchange for new construction.

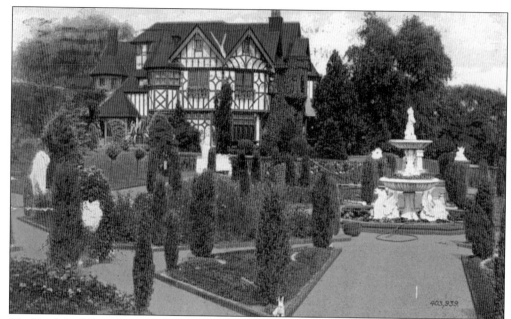

"As You Like It" was one of the showpieces of Belle Haven when this image was taken in 1907. The half-timbered facade takes one back to the time of Shakespeare, although the topiary garden would not seem to bear a very close resemblance to the Forest of Arden. The fountain at the right is supported by winged gryphons, and there is a small stone rabbit keeping watch at the very bottom center of the image. The house was built by local benefactor Nathaniel Witherell as a summer home, the same purpose for which many other Belle Haven cottages were originally built.

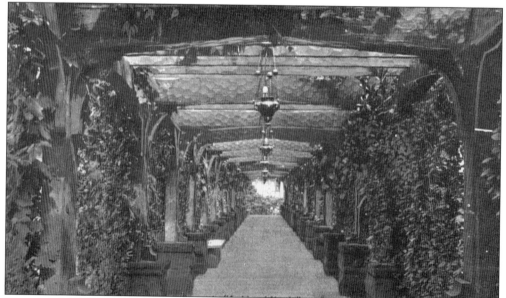

The pergola at As You Like It was draped with hanging vines and greenery. A series of lanterns suspended from the crossbeams leads the eye up to the half-timbered wall of the house. Obviously, the Witherells lavished a great deal of care and attention on their home, and they managed to create a fantasy world around them that was clearly to their liking.

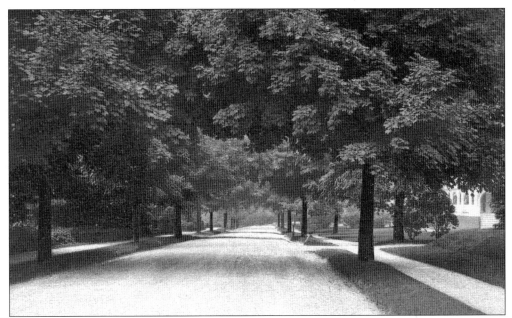

The roads in Belle Haven in 1907 were rustic and tree-lined, affording both beauty and privacy to the homeowners. Mayo Avenue was the address for As You Like It, as well as for Edward Hamilton Malley, the department store magnate whose outlets once gave Macy's and Gimbel's a run for their money.

Glenwood Drive led toward the water and the Belle Haven Club (then known as the Casino) and the Graham residence. Today, the lone wagon in this 1907 picture would have to compete with the cars heading to the tennis courts and pool; perhaps that is one reason why most of the roads in Belle Haven now have speed bumps or fences to remind people to drive slowly.

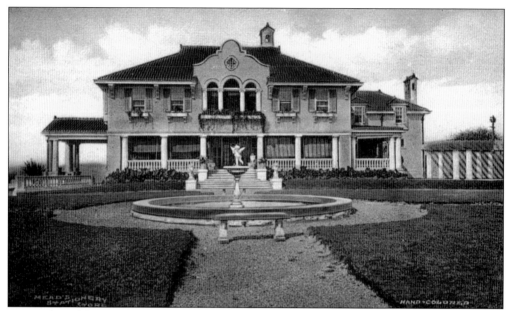

Iron and steel baron John Haldane Flagler built this Spanish Mission–style cottage on North Street. The writer of this 1910 postcard wryly notes, "This is another one of the small houses of Greenwich." Known as Northbrook Farm, the main house had all the amenities, including a pipe organ. It burned down in 1920, and no trace of it remains today.

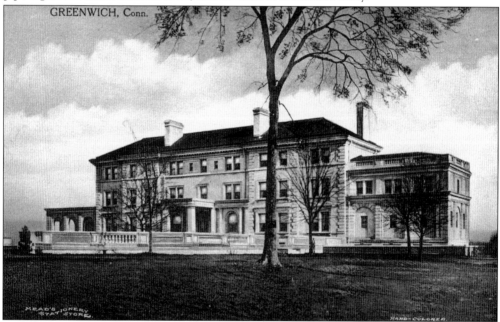

The Percy A. Rockefeller residence, Owenoke Farm, as seen in this 1910 view, was befittingly among the largest in the area. Its grand front was over 200 feet long and, with 64 rooms, it was hailed as "Our Stateliest Mansion" by the local paper. Even by today's standards, as older houses throughout the town are being torn down to create enormous new residences, the Rockefeller home could probably hold its own in terms of square footage. It was demolished in the late 1930s and was so solidly built that the wreckers had to use dynamite.

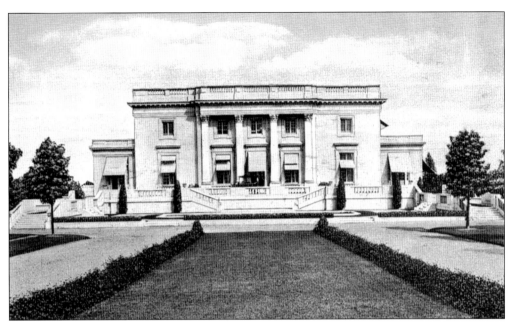

"Northway," the home of heiress Laura Robinson on North Street, was built from 1910 to 1913 and was modeled after the Petit Trianon at the palace of Versailles. Set at the end of a long driveway, its dazzling white facade is one of the town's landmarks. The house is currently owned by the Anselmo family; the late René Anselmo was the founder of Comsat, a communications satellite company. It was Anselmo's generosity that led to the profusion of daffodils that appear every spring along North Street, as well as the handsome wooden street signs placed throughout much of the town.

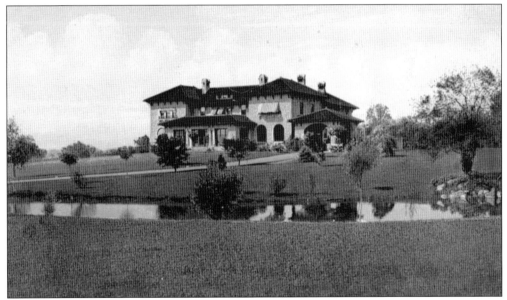

Also on North Street was the J.G. Hopkins residence, built in the Mediterranean style. In this 1907 view, the trees and plantings are rather young, as North Street was still relatively undeveloped at that time. Later, the street became known as the Greenwich equivalent of Fifth Avenue.

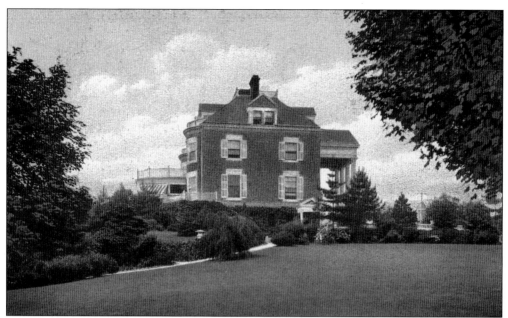

The C.T. Mills residence, seen here in 1907, was one of the handsomest Georgian-style homes of the period. The large two-story front portico presents an imposing facade to the world, while the rounded contours of the back soften and humanize the effect for family and visitors.

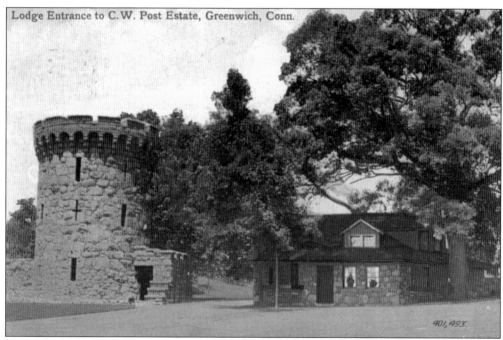

By contrast, most people probably never got beyond the rather forbidding entrance to the C.W. Post residence on Glenville Road at the time this view was taken in 1907. Clearly Post valued his privacy and considered his home his castle. Later, the estate became home to the Edgewood School and, today, it houses the Eagle Hill School. Dozens of cars now pass in and out daily.

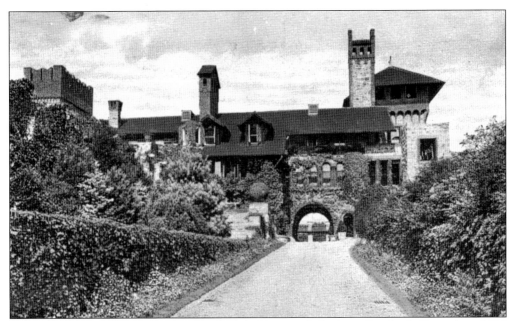

Not far from the Post estate is the equally forbidding castle built on Brookside Drive from 1903 to 1906 by James C. Green. It provided the settings for several classic Hollywood silent films, as well as for a more recent one, *The April Fools*, with Catherine Deneuve and Jack Lemmon. The writer of this 1916 postcard was taking a vacation from Brooklyn, whence came great numbers of summer visitors to Greenwich; he reports having taken a "fine motor boat ride" the previous day to view some of the "beautiful estates along the shore."

Brookside Drive, which led to Colonel Green's castle, was unpaved at the time, as seen in this 1907 view. It was not paved until the beginning of World War I, perhaps all the better to film *Cinderella*, *The Perils of Pauline*, and *When Knighthood Was In Flower*. Magic carriages and warrior steeds tend to do better on dirt roadways.

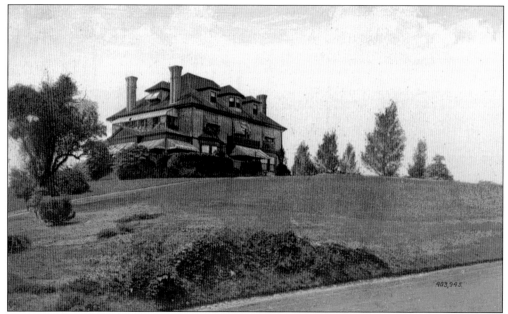

This in-town estate, Sunset Hill, still stands on Dearfield Drive as it did in 1907, just north of busy Putnam Avenue (U.S. Route 1). Unlike other areas close to the center of town, this street has been spared the fate of commercial development. On a side street nearby, Grove Lane, is the boyhood home of former president George Herbert Walker Bush, who grew up in Greenwich before going off to serve in World War II. After the war, he married Barbara Pierce of nearby Rye, New York, and started his family, including current president George W. Bush.

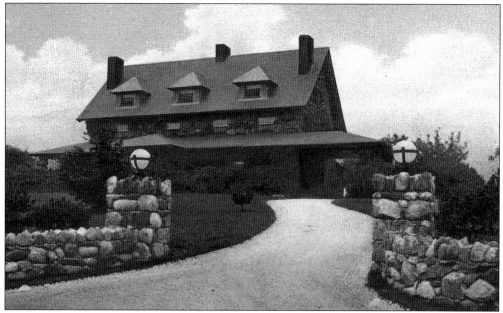

The Edward Rossiter residence, seen in this 1907 view, featured stone construction in an Adirondack style of architecture. Stone walls were a popular feature of many estates and, in fact, continue so down to the present; at any given time, one can still see them being built around town, although today's walls tend to be higher than Rossiter's.

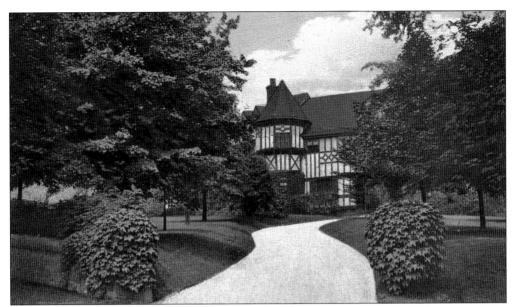

The Tudor style was also popular among the homebuilders of the early 20th century. The W.R.H. Martin estate featured a half-timbered front with a round turret, as seen in this 1908 view; the slightly later view of "Grasshopper Farm" features a large mullioned window with leaded glass, ivy-covered chimneys, and flowering plants hanging from window boxes on the second story.

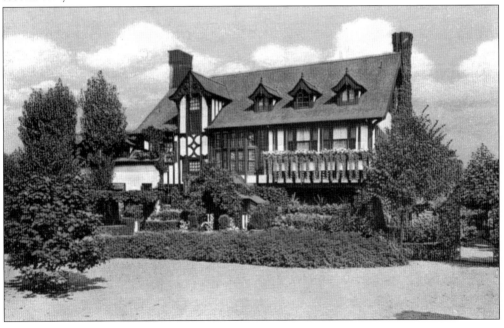

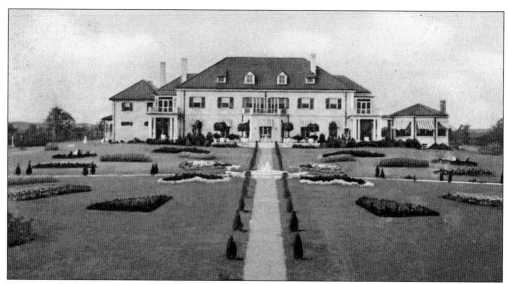

Way up on the Connecticut-New York line lies Conyers Farm, once a working farm and dairy. Its more than 1,300 acres made it by far the largest privately owned tract of land in town, and at its height it employed nearly 200 people. The main house was built c. 1904 by banker Edmund C. Converse; after his death his widow sold it in 1927 to Frederick Sansome, who renamed it Homewood Farms, as seen in this period postcard. Today, the property is being subdivided in large parcels that should help to ensure that most of its natural beauty will remain unspoiled.

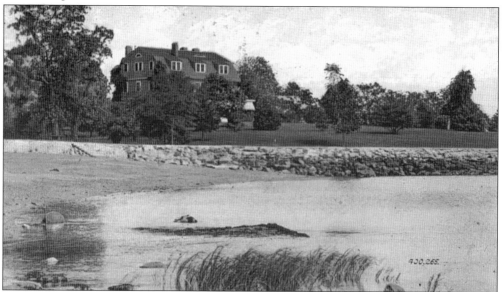

The W.H.S. Woods estate was on Mead's Point, now a private gated community. About 10 years after this picture was taken in 1908, the town threatened to take over part of Mead's Point for a public beach. The local landholders got together to try to find an alternate piece of waterfront property to give to the town in exchange for their beach. Legend has it that the Lauder family drew the short straw, and history records that they graciously bought Island Beach and donated it to the town. Everyone was happy: the Mead Point Association was able to close its streets to the public, and the townspeople had a magnificent sandy beach.

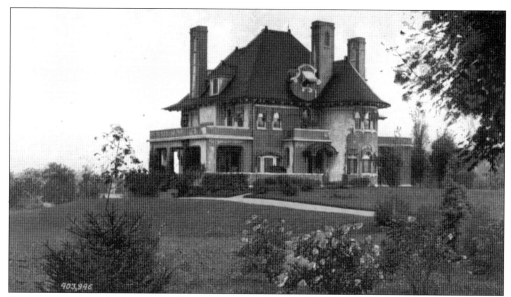

At the western end of town, Walter B. Todd built his stone mansion, with its high-pitched red roof, on Glenville Road. The fancy dormer window and thick chimneys proclaim Todd as a man of substance, while adding architectural interest at the same time. At the time this image was made c. 1910, there were few large mansions nearby; that situation would change within a decade or two.

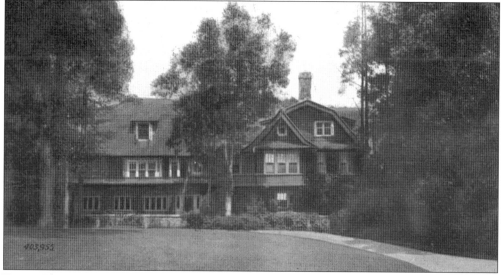

Ernest Thompson Seton (1860–1946) was a founder of the Boy Scout organization in the United States, and his house and land were part and parcel of his commitment to the Boy Scouts of America (BSA). "Wyndygoul," as the estate was known, was also home to the historical writer Barbara Tuchman for many years. The town of Greenwich has recently purchased this gorgeous piece of property, right in the middle of Cos Cob, less than a mile from Routes 1 and I-95. Hiking trails and tree stumps gathered around a stone-encircled bonfire pit show that Seton used these woods for the benefit of the Scouts, and it is now a possibility that the local BSA chapter may occupy Seton's former residence for its headquarters. Unfortunately, the third story fell victim to a fire.

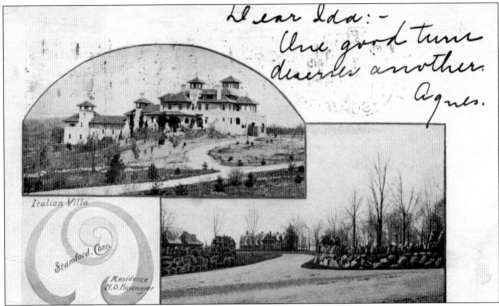

Mansions, as well as inns, dotted the Old Greenwich landscape long ago, and one of the largest was that of Henry O. Havemeyer, the "Sugar King" (1817–1907). His estate, Hilltop, is shown in the lower image of this 1905 postcard and still stands in Hillcrest Park. Havemeyer donated the high school on Greenwich Avenue, now known as the Havemeyer Building, home to the board of education. After World War II, part of his estate became a housing development for returning veterans, now named Havemeyer Park.

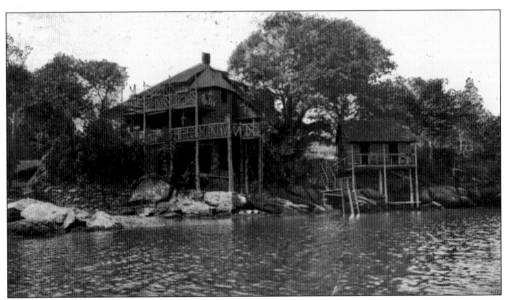

Crest Eyrie was also situated in Old Greenwich. Its architecture suggests that of a bird's nest leaning out over the water, as seen in this 1908 image. The bathhouse at the right has a set of rickety stairs leading to a ladder into the water. Obviously the owner tried to make the best of the rocky shoreline, but unfortunately this fanciful structure no longer survives.

Six

THE LIFESTYLES OF THE RICH AND FAMOUS

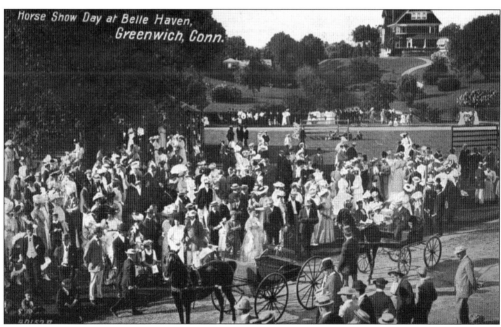

This wonderful 1906 image shows Horse Show Day at the Belle Haven Club, a tradition which began in 1890 but ended with the Panic of 1907. The period costumes constitute Edwardian finery at its apex. The horse jumps are set up where the tennis courts are currently situated, on which Ivan Lendl has occasionally given members the chance to volley with him ("I was playing against Lendl the other day . . ."). Then as now, Belle Haven has always been one of Greenwich's most gracious clubs.

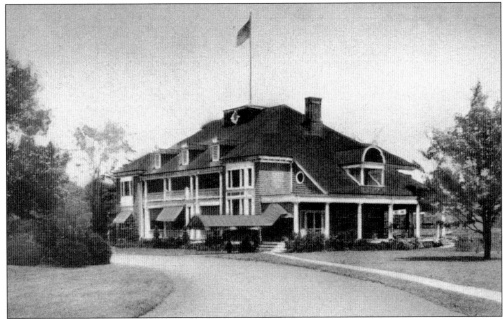

Belle Haven, like one or two other prestigious Greenwich clubs, is situated on Long Island Sound, and the view looks out across the water toward the town-owned islands and Long Island in the distance. Part of a private community with its own taxing authority and police force, Belle Haven nonetheless allows "outsiders" from the rest of Greenwich to join its ranks, though they must stay on a waiting list until all those within the precincts have been accommodated. In the old days, it was known simply as the Beach Club and, in even earlier days, the Casino.

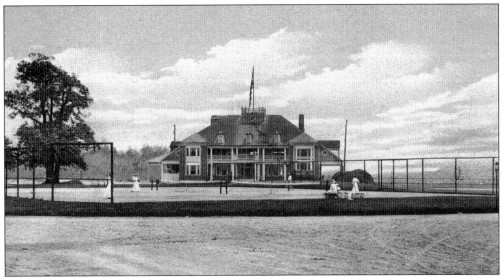

This view of the Casino was obviously taken after the Horse Show Day, as the tennis courts are now in place. All the players seem to be women in their voluminous tennis whites. Thankfully, today's dress conventions allow the ladies considerably more freedom to move about the court. Rarely does one see the club's courts as empty as in this 1908 view; the sign-up sheets are usually filled days in advance.

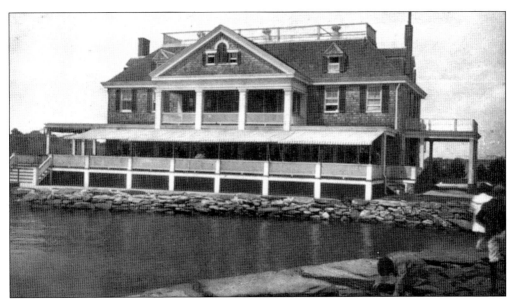

Also on the waterfront, the Indian Harbor Yacht Club is home to one of the most serious sailing groups in the world. This is the old clubhouse, as seen in 1905; it burned down in 1919, and the current one is somewhat smaller. Note the children playing on the pier at the right, which is now town property and a favorite hangout for fishermen. Should you be invited to the club as a guest, you will see hull models of historic boats that have participated in many competitions, including the America's Cup. Situated right at the mouth of Greenwich Harbor, the club has been host to many visiting yachtsmen from the world over. The late Malcolm Forbes of *Forbes Magazine* used to bring his enormous *Highlander* in every July.

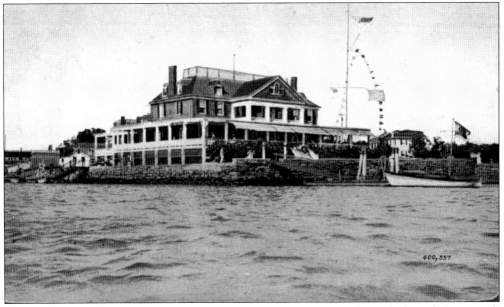

This view of the old Indian Harbor Yacht Club was taken c. 1908. The end of South Greenwich Avenue, now Steamboat Road, can be seen at the right; one of the old harborside warehouses is visible at the far left. The colorful flags and the presence of a large crowd on the porch suggest that this may have been a holiday such as Commissioning Day or the Fourth of July.

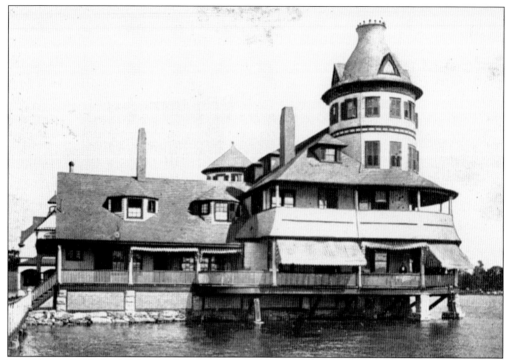

The Riverside Yacht Club members are also serious sailors. Situated at the mouth of Cos Cob Harbor where the Mianus River flows into the Long Island Sound, the club sponsors frequent races and sunset sails. This 1905 view shows the old Victorian clubhouse built in 1889; a couple of well-dressed gentlemen are standing on the porch, perhaps discussing whether they should go out in their sailboats.

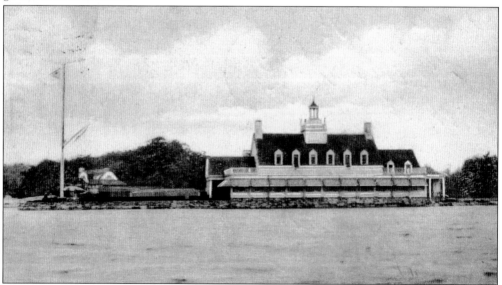

This is a 1930s view of the current clubhouse, which was built on the site of the old one in 1929; the large Victorian tower has given way to a more modest cupola. This photograph was taken in the off-season so as to show the building more clearly; in summer it is surrounded by a forest of masts.

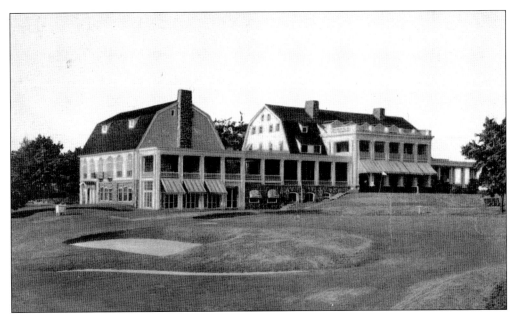

The Greenwich Country Club has one of the best golf courses in the area, with lovely views out over Long Island Sound. The old clubhouse, built in 1911, burned down in 1929. Its successor, seen here c. 1930, also burned to the ground in 1960 and has been replaced with a more modern but equally gracious and presumably more fireproof building.

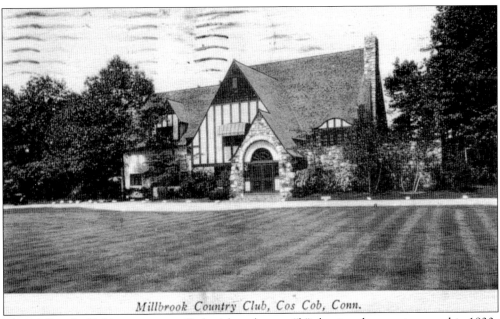

The Milbrook Club's name is spelled with only one "l," despite the caption on this 1930s postcard. Nor is the club usually considered to be in Cos Cob, as the houses that were built around it in the early decades of the 20th century are all in the private Milbrook association. Like the Belle Haven area, Milbrook maintains its own roads, its own police force, and its own neighborhood identity. The clubhouse opened in 1926 and has been extensively renovated in recent times, but still retains its English country charm.

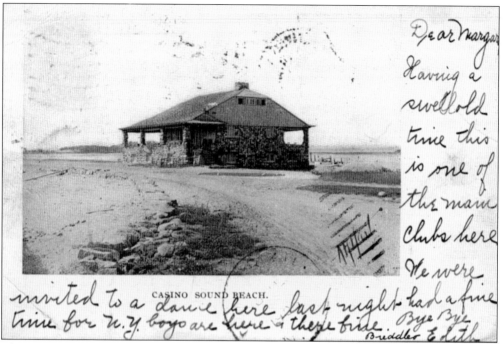

This rare 1905 view shows the Casino in Sound Beach, now Old Greenwich. The message pretty much says it all: "Having a swell old time. This is one of the main clubs here. We were invited to a dance here last night [and] had a fine time for N.Y. boys are here and [they're] fine." One can imagine couples strolling along the beach in the moonlight while dance music wafted out from the Casino.

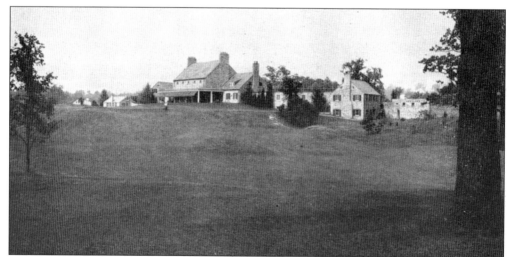

The Round Hill Club has always tended to be the grande dame of Greenwich country clubs. This view from the late 1920s shows its extensive buildings and hints at the vast expanses of land around it. Some may say that the tennis is better at the Field Club or the golf is better at the Stanwich Club, but few would argue that the prestige of belonging to Round Hill is the *ne plus ultra* of local club memberships. One thing is certain: Greenwich is blessed with many beautiful country clubs, almost all of which have some form of reciprocity with each other; thus, to belong to any of them is to enjoy club life at its best.

Seven
THE NEIGHBORHOODS

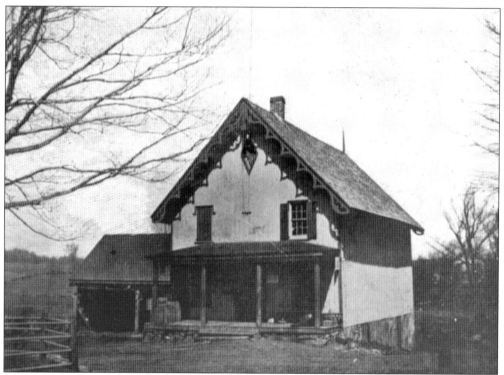

Many outsiders do not realize that Greenwich comprises half a dozen smaller towns, several of which have their own zip codes. These include Old Greenwich (site of the first settlement), Riverside, Glenville, Cos Cob (once home to a well-known artists' community), Banksville, and Byram. Other neighborhoods include Pemberwick, Chickahominy, Mianus, Stanwich, Quaker Ridge, Round Hill, Milbrook, Rock Ridge, and Havemeyer Park. This 1905 view shows the M.N. Finch & Sons store in the community of Banksville, which straddles the Connecticut-New York border. Until 1899, the Banksville Stage made regular runs up North Street to and from downtown Greenwich.

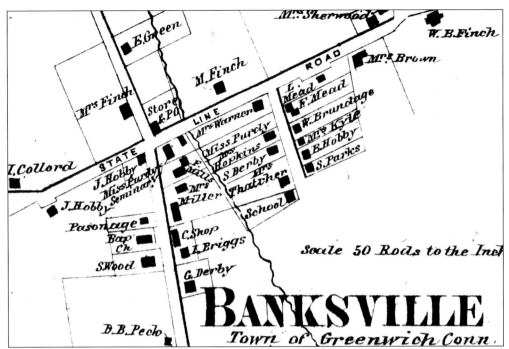

This 1867 Beers Atlas map of Banksville shows the location of the Finch store on the previous page, as well as other Finch properties nearby. William E. Finch Jr., a scion of this family, was the local town historian for many years of his prodigiously productive life, and this is as appropriate a place as any to pay tribute to him and to his work. If you visit the Historical Society of the Town of Greenwich, you will see that the archives are named in his honor. In fact, he used to live at the Bush-Holley House, the society's showpiece. All in all, one cannot legitimately say one has seen Greenwich without a visit to the place to which Bill Finch dedicated so much of his life.

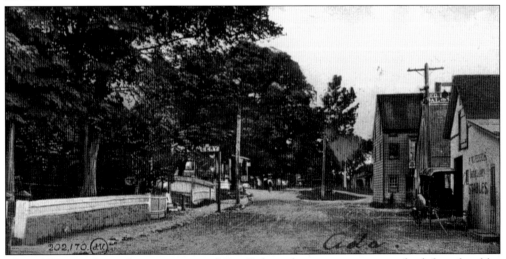

This 1907 view shows the main street of Cos Cob, with a grocery store on the left and stables on the right. The dirt roadway bears the tracks of buggies, like the one parked outside the F.W. Ferris stables. For many years this area was one of the main providers of vegetables to the New York City market.

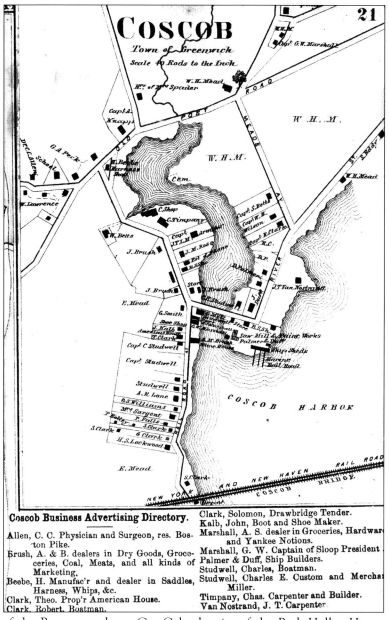

Coscob Business Advertising Directory.

Allen, C. C. Physician and Surgeon, res. Boston Pike.
Brush, A. & B. dealers in Dry Goods, Groceries, Coal, Meats, and all kinds of Marketing.
Beebe, H. Manufac'r and dealer in Saddles, Harness, Whips, &c.
Clark, Theo. Prop'r American House.
Clark, Robert, Boatman.
Clark, Solomon, Drawbridge Tender.
Kalb, John, Boot and Shoe Maker.
Marshall, A. S. dealer in Groceries, Hardware and Yankee Notions.
Marshall, G. W. Captain of Sloop President
Palmer & Duff, Ship Builders.
Studwell, Charles, Boatman.
Studwell, Charles E. Custom and Mercha[nt] Miller.
Timpany, Chas. Carpenter and Builder.
Van Nostrand, J. T. Carpenter

This part of the Beers map shows Cos Cob, the site of the Bush-Holley House, the Finch archives, and the town's historical society. The center of Cos Cob is known as the "Hub" and, in fact, the village is the axis on which the rest of Greenwich and much of New England turns. For the better part of a century, its power plant provided the electricity to the railroad between Boston and New York; the old Post Road has passed through it for centuries; and even I-95 (with the occasional bridge collapse) passes through or over it. The famed Clam Box Restaurant was the intelligent traveler's choice for many decades, but it has since given way to a New York bank and some nondescript condominiums. Nonetheless, Cos Cob retains a strong neighborhood identity, and those who live there are quite proud of the fact. Justifiably so, for much of the literary, social, and artistic achievements associated with the town of Greenwich originated right here.

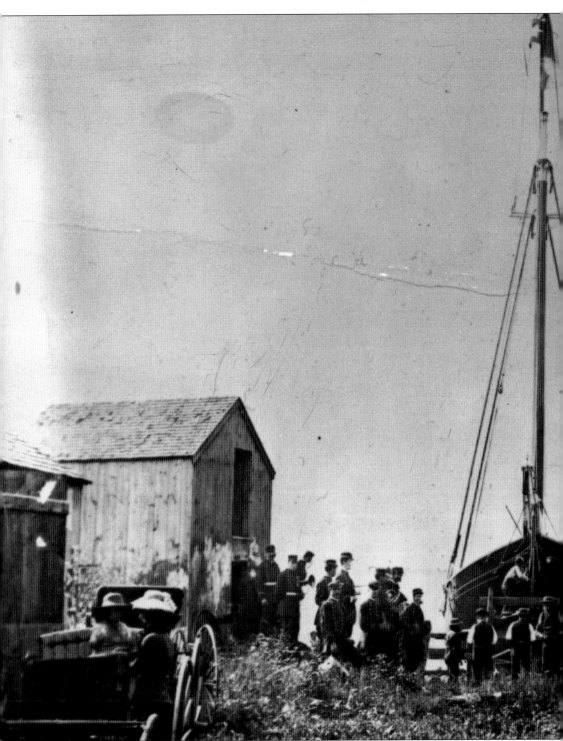
The Palmer and Duff shipyard in Cos Cob was situated on the Mianus River just before it empties into Long Island Sound. Here, a new boat is being launched with the proper festivities, flying the Stars and Stripes at the masthead and attended by numerous ladies and gentlemen

in their Sunday best. This view dates from *c.* 1890; within a few years, the railroad would render the shipyard obsolete and the Greenwich produce sent to New York City would travel by land rather than sea.

This is a view of the Lower Landing in Cos Cob c. 1900. The old village post office is in the center; it is now part of the town's historical society. To the left is a large rooming house, shown on the Beers map as the Americus House owned by Theo. Clark, where visitors to the local art

colony would stay. Elmer MacRae, John Twachtman, and Childe Hassam were among those who found this little riverside village an idyllic spot to paint; their works can be seen locally at the historical society and the Bruce Museum.

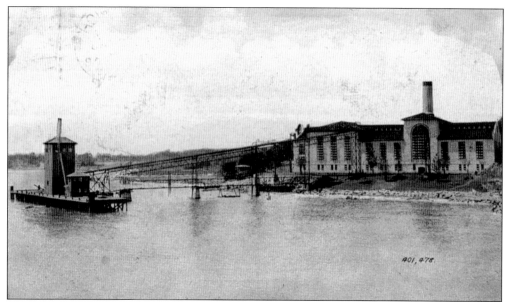

This 1908 view shows the "Electric Power House," better known as the Cos Cob power plant, which was an important mainstay of the old New York, New Haven, and Hartford Railroad. Its giant turbines were state-of-the-art for the time and continued to provide power into the 1980s. The wharf at the left received the shipments of coal that fueled the plant; the coal traveled by conveyor belt up to the furnaces. When the plant shut down, the town bought the site for $1 and tore the building down; eventually, the area will become a public park.

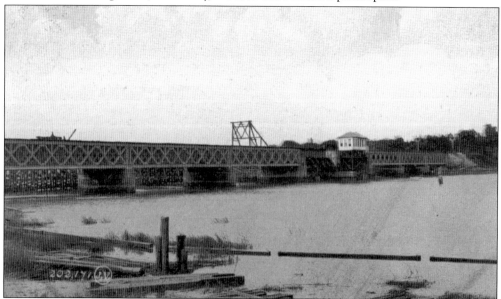

Just beyond the power plant began the long drawbridge that carried the train tracks across the Mianus River. The middle portion of the bridge still goes up and down many times a day, but now it is used by high-masted and high-powered pleasure boats rather than by vegetable carriers. The actor Edwin Booth, who lived near the western end of the bridge, used to jump off the train as it slowed down to go across. One night he misgauged his leap and landed in the river, where he drowned.

This view was taken from the railroad bridge itself and shows the Cos Cob shoreline along Strickland Road as it appeared c. 1908. According to the Beers map, the "drawbridge tender" Solomon Clark owned several house lots toward the left of the photograph, giving him an easy commute to his job. The village center can be seen off at the right. The large building at the left occupied what is now the site of a sewer pumping station; nearby lies the present-day Mianus River Boat and Yacht Club, whose older members spend long hours on the front porch and are known as the "tidewatchers." They have always wanted to be mentioned in a book, and now they have been.

Just past the old center of Cos Cob lies the Mill Pond, also known as Strickland's Pond. This early-20th-century view shows some of the houses and buildings in what is now a historic district lying between the Mianus River and the Post Road. Over the years the business center of Cos Cob has migrated from the Lower Landing to the Hub, where Strickland Road joins the Post Road. A few of these old houses are still standing and have been lovingly preserved.

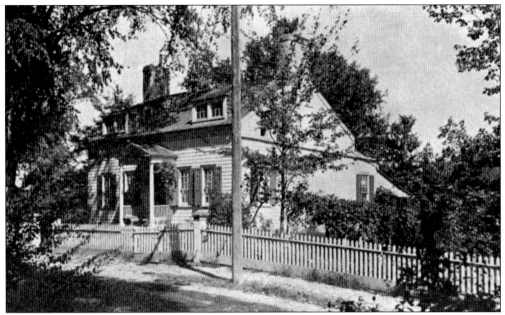

One such house is that built by Captain James Waring in 1749, still standing close to the road as it did in this 1920s view. Nearby is the Mill Pond and a pocket park with one of the town's oldest graveyards. Not far away lies I-95 and its ill-fated span across the Mianus River that collapsed in 1983, killing three people and snarling traffic in town for many months while it was being rebuilt.

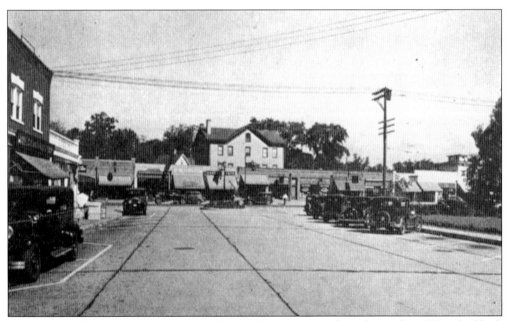

Here is the Hub of Cos Cob as it appeared some 70 years ago. After a fire in the 1980s, the block of stores in the center of the picture was rebuilt in brick, with the locally owned Food Mart as the anchor. For a while the Cos Cob library had its home there until it moved to its handsome new building behind the fire station.

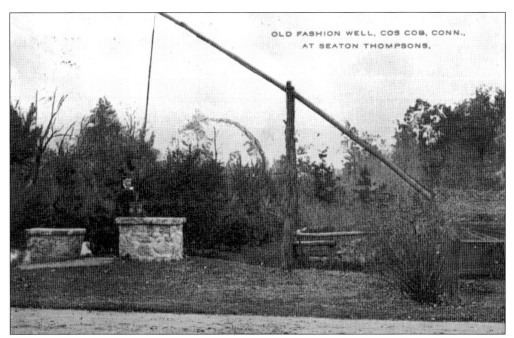

Just a little way north of the Hub lies the former estate of Ernest Thompson Seton, founder of the Boy Scout movement in America. This gorgeous preserve of woods, lake, and streams sits in the middle of a busy residential area less than a mile from the perennially clogged Connecticut Turnpike (I-95). The town, in its wisdom, recently acquired this splendid property, and there is a possibility that the local Boy Scout council may use Seton's house as its headquarters. As Seton used his property for numerous Scouting activities, one imagines this prospect would delight him. The hiker can still see old fireplace encampments and other relics of Seton's time, although this old-fashioned well and the log cabin have vanished.

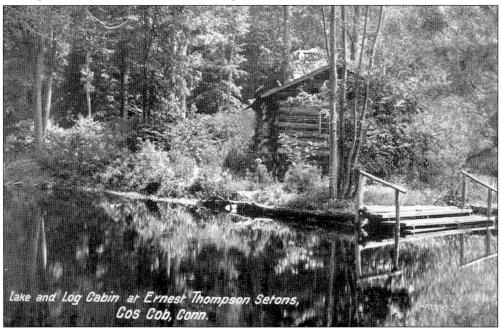

Here are two more views of this lovely property as it appeared c. 1908. Unlike so many of the scenes in this book that no longer exist, the reader can still visit the preserve today, its tranquil beauty unchanged by the years. The late historian Barbara Tuchman lived on an adjacent piece of property, which the town is also attempting to acquire. In conjunction with the nearby Montgomery Pinetum, this tract would form a large preserve of unspoiled woods and streams virtually unparalleled elsewhere in the midst of a rather densely populated and increasingly urbanized area.

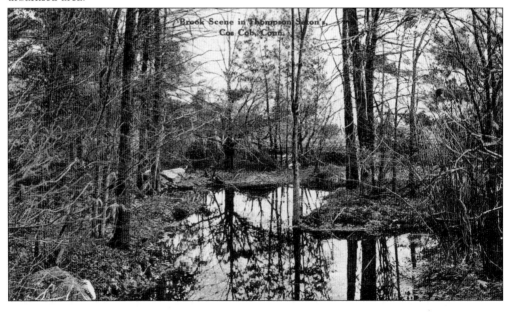

The area of town once known as Mianus was named after an extinct Indian tribe; its memory survives chiefly in the North Mianus elementary school, which today serves parts of Riverside and Old Greenwich. The 1867 Beers map shows how vital the bridge was to the main highway between New York and Boston. The business advertising directory includes an S. Sturdevant, Photographer & Broom Maker. The art of photography was in its early infancy in those days, so it appears that Sturdevant also kept his day job in the broom industry.

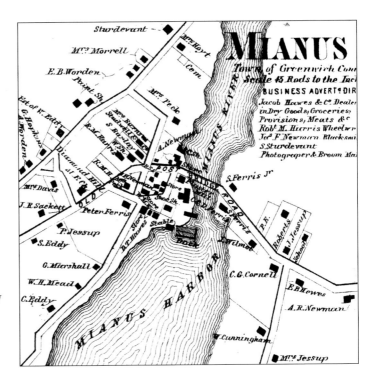

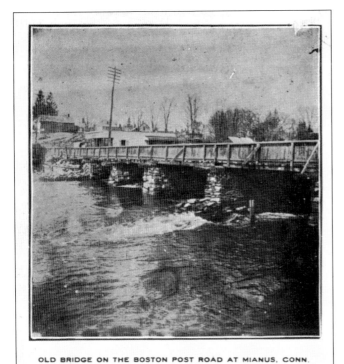

OLD BRIDGE ON THE BOSTON POST ROAD AT MIANUS, CONN.
"Where the Sound drinks the small tribute of the Mianus."
—Whittier.

This charming 1907 postcard view shows the old wooden bridge that used to carry the Post Road across the Mianus River; it has long since given way to a more modern four-lane bridge, which serves as a useful alternative to the frequent traffic jams on nearby I-95. The poetic tribute from John Greenleaf Whittier is a rare mention of a Greenwich locale in 19th-century literature.

105

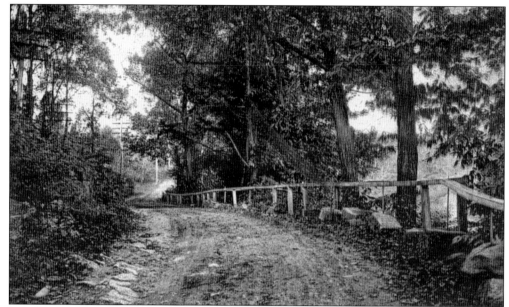

On the other side of the bridge lies Dumpling Pond, named for the Colonial housewife who threw her dumplings into the water rather than let them fall into the hands of British soldiers. This 1907 view of the dirt road bordering the pond shows how rustic Greenwich was in those days, even though the telephone poles lining the left-hand side indicate that progress was on the march.

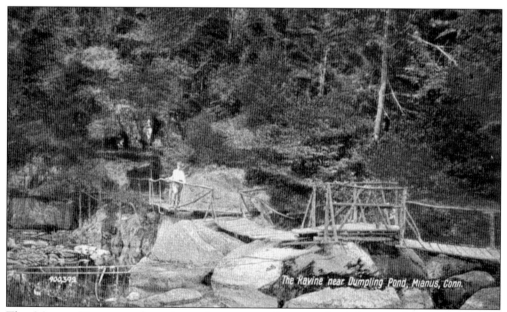

The Mianus River area has always been a popular area for hikers, and with the recent acquisition by Greenwich and Stamford of the Treetops property, former home of torch singer Libby Holman, there is now a "green belt" extending well into New York State. One can hike for many pleasurable hours along the extensive trail system. The wooden walkway on which the boy of 1907 is standing no longer exists, but the pond is still a popular spot for skating after a hard freeze.

Across the Mianus River from Cos Cob lies the residential community of Riverside. These two 1907 views show how rural this area used to be; the dirt road to the yacht club is bordered by fields and a single house. Not so today. Lover's Lane has long since vanished, as have the adjacent meadows. Open space such as this is increasingly hard to find in present-day Greenwich.

The back-country Stanwich area used to have its own post office, as well as more of a neighborhood identity than it has today. This 1905 view of a waterfall is one of the few reminders of this former Greenwich community.

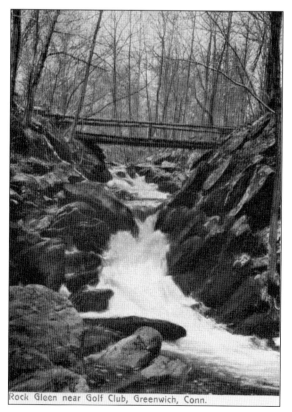

Rock Gleen near Golf Club, Greenwich, Conn.

Golf came early to Greenwich, as shown by the title of this 1906 postcard. Wooden bridges such as this one were once common in the back country but, today, only one remains, on Cliffdale Road. Proposals by the state to modernize it are met with stiff resistance from area homeowners, who recently had Cliffdale designated as a scenic road.

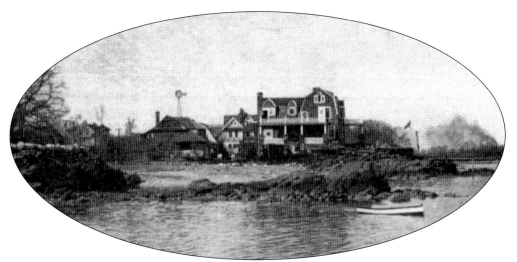

Sound Beach, now known as Old Greenwich, was a shoreline resort community in the late-19th and early-20th centuries. This 1905 view shows a seaside cottage, complete with outbuildings and a windmill. Off to the right rises a heavy plume of black smoke, which may signal the passage of an old coal-burning train; the Cos Cob power plant would not yet have been in operation, although in a year or two it would also be sending forth smoke and the fine black ash that used to plague nearby residents.

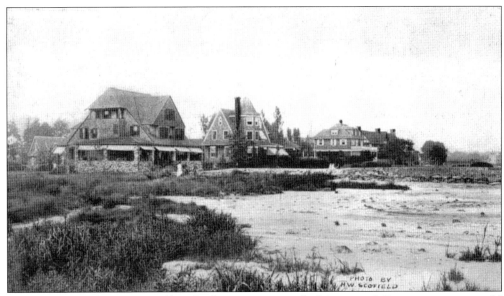

This 1907 view shows a row of beachside cottages typical of the period. Summer visitors would come to one of the nearby inns, often for the whole season, and later wind up buying property and building their own summer homes such as these.

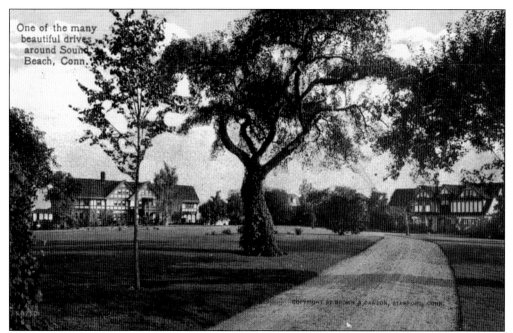

This 1908 postcard view is titled "One of the many beautiful drives around Sound Beach, Conn." These particular cottages were somewhat more lavish than usual and illustrate how the area at one time was beginning to vie with Belle Haven in elegance. Belle Haven won out, perhaps partly because it managed to remain a private neighborhood and did not have to cope with the much heavier traffic in Old Greenwich.

Laddins Rock Farm straddled the Old Greenwich-Stamford border and, as seen in this 1905 view, was a popular place for hiking and horseback riding. At one point there were hopes of turning this extensive property into a public park, but the developers won out.

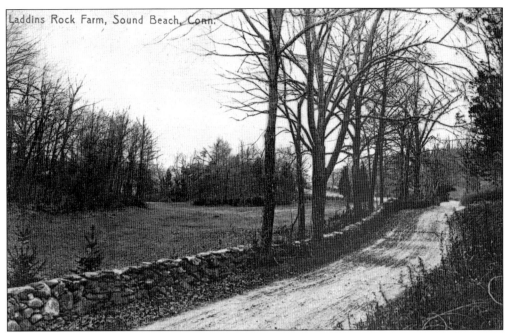

These two views show how rural and serene Laddins Rock Farm was c. 1910. Today, the area is a housing development and the swans have had to find another place to nest.

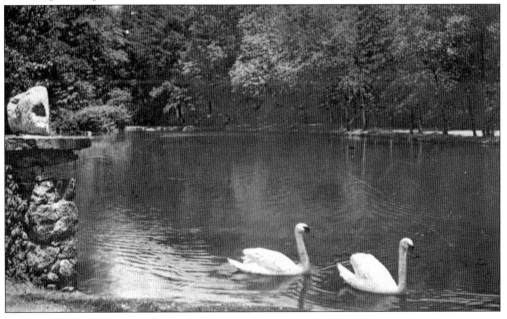

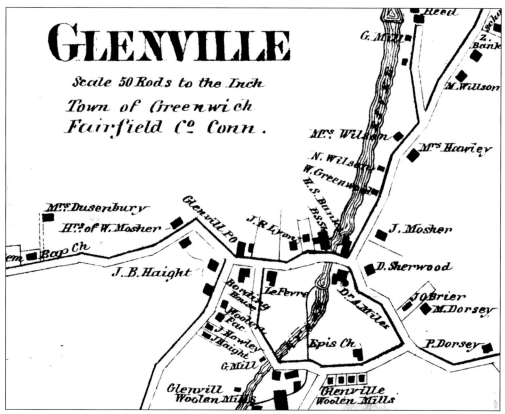

At the western end of town was the industrial area of Glenville, where the Byram River furnished power for the mills in the 19th century. The 1867 Beers map shows the rather extensive layout of the mill complex.

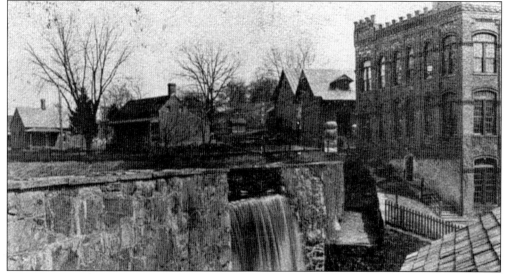

These are the Glenville woolen mills as they appeared c. 1907. Many of these old buildings still stand; today, they have been refurbished into an upscale office, shopping, and restaurant complex.

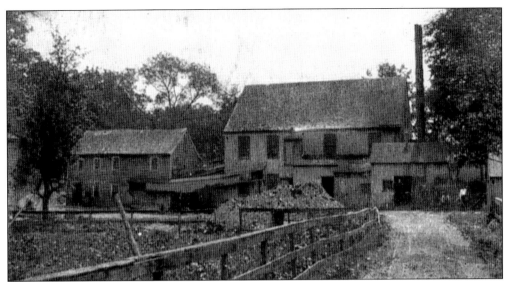

Nearby stood Reynolds mill, also utilizing the power of the Byram River. Today, much of the riverside area is protected conservation land, starting with the Audubon Society properties on Riversville Road and North Porchuck Road. Hiking trails along the river and the gorges it creates continue southward through pockets of town-owned parkland; few people are aware of these lovely areas of natural beauty as they rush by on their way to schools and soccer games and shopping.

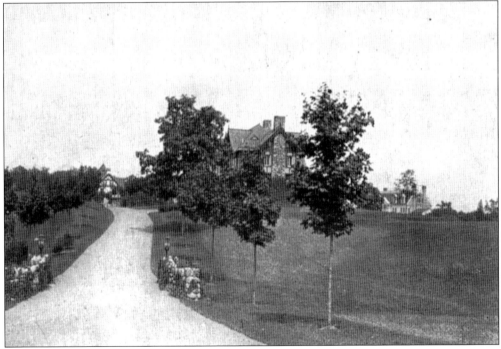

This early-20th-century view from King Street shows that despite the then industrial character of the Glenville-Pemberwick district, some chose the area as a place to build fine homes, such as the three shown here. Today, King Street carries an unending flow of school, business, and airport traffic and has lost the pastoral character of 100 years ago.

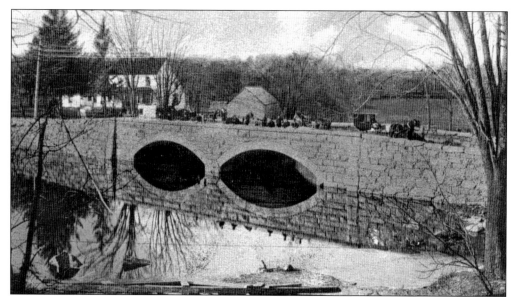

As the Byram River made its way south from Glenville to the ocean, it gave its name to the village of Byram, which has had many different names over the years, including Hawthorne, Meadville, New Lebanon, and East Port Chester. This 1907 view of the bridge at the New York State line shows a large number of people standing to watch the photographer at work; a horse-drawn carriage waits patiently at the right. This bridge is still in use today, although a second one has been added to cope with the increased traffic.

When the second bridge was added in 1927, the Thomas Lyon Homestead, dating from 1670, was relocated from the north to the south side of the Boston Post Road by the Rotary and Lions Clubs of Greenwich. Still a Byram Hill landmark, it serves as part of the gateway to New England at the Connecticut-New York border.

Eight
THE PARKS, ISLANDS, AND BEACHES

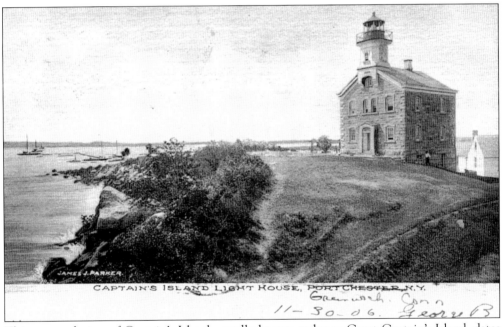

This postcard view of Captain's Island, usually known today as Great Captain's Island, dates from 1906. The writer has crossed out "Port Chester, N.Y." and added in "Greenwich, Conn." to correct the publisher's mistake. Since the island lies off the coast of Byram, which was earlier known as East Port Chester, the error is understandable. The lighthouse was built in 1868 and is essentially unchanged, although the light itself is now atop a utilitarian steel tower nearby. A move is afoot to restore the building as a functioning lighthouse. The island, which contains a bird sanctuary for nesting egrets, can be reached by a town ferry, but only at high tide.

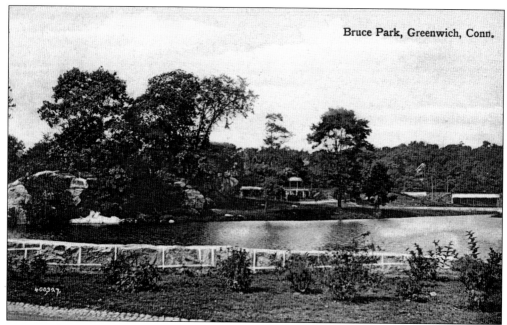

Bruce Park is a lovely expanse of ponds, lawns, flowers, and colorful trees near Indian Harbor. In earlier times, from 1709 to 1889, a tide-powered mill was located here; today, there are town tennis courts and a beautifully-maintained greensward for lawn bowling. The park is named for the Bruce family, who donated the land to the town in 1909 and whose nearby mansion is part of the extraordinary museum that bears their name.

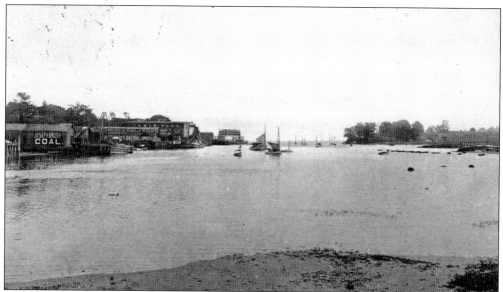

Visitors to the town's islands leave from a ferryboat pier at the bottom of Greenwich Harbor, near where this 1905 view was taken. The Joseph Brush coal warehouse is long gone, replaced by a modern office building built for General Reinsurance. The other warehouses have given way to waterside condominiums and offices. On the left at the end is the old Indian Harbor Yacht Club, which continues to occupy its prime site in a newer building. The trees at the right mark the site of Round Island.

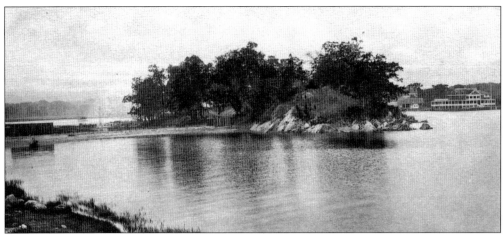

Here is a closer view of Round Island, also dating from 1905 and showing the old Indian Harbor Yacht Club in the background on the right. At the time this view was taken, Round Island was a popular picnic and swimming spot; in fact, the town had made an offer to buy it as a public beach in 1895. The residents of Belle Haven preferred to keep their privacy, and the sale did not go through. It was bought instead in 1908 by John D. Chapman, a New York stockbroker, who built a handsome Tudor style mansion on the property. For many years, Round Island was the home of Frederick and Patricia Supper, also of Palm Beach, who were active in their support of the arts and the game of croquet. After their deaths, the island was bought by the uncle of Dodi al-Fayed, who renovated the property extensively in hopes that his nephew and Princess Diana would use it as their American home after their marriage. This, alas, was not to be.

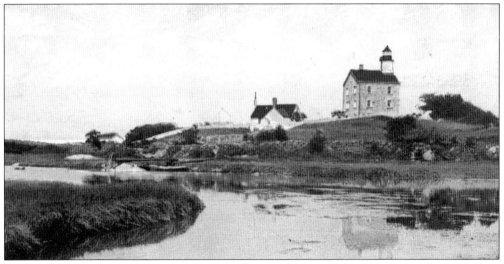

Taking an imaginary ferryboat ride out to Great Captain's Island, one would pass Round Island, Indian Harbor Yacht Club, the former Benedict mansion, and some of the Field Point waterfront homes. Waterfront property has always been among the most desirable in town and remains so to this day. In the early 20th century, one could take a sightseeing excursion by boat to view some of these estates; today, the ferryboats still provide a wonderful way to see the homes of noted residents such as the late Victor Borge and Thomas J. Watson Jr. Here is another view of the largest of Greenwich's islands, showing the tidal salt marsh near where the egrets nest in the spring and early summer.

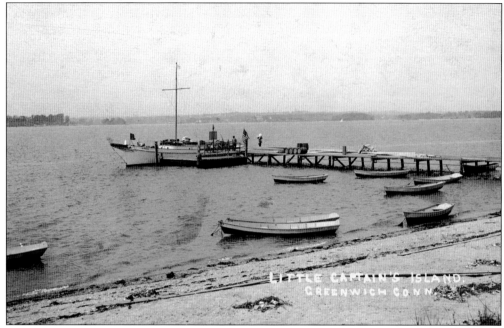

This 1920s photograph shows the pier at Little Captain's Island, popularly known as Island Beach, with a yacht tied up at the end and several smaller boats anchored nearby. Originally a private amusement park when it opened in 1912, the island was later given to the town by the Lauder family in memory of a son killed in World War I. During the summer months, two town ferryboats ply back and forth bringing beachgoers to this lovely park.

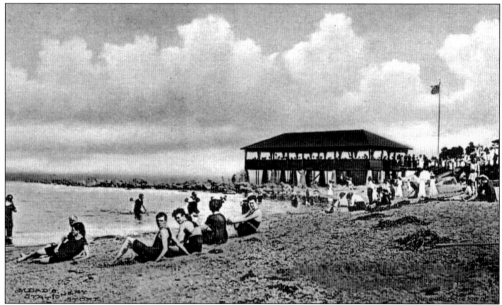

This Island Beach scene, typical of the early 20th century, shows the bathing costume of the period, when even the men wore shirts. Nary a Speedo or bikini to be seen. Today's view is quite different, as even the large bathhouse is gone, carried away by a recent hurricane that left only the concrete foundations in its wake.

A boy running along an otherwise empty beach in Old Greenwich in 1908 is a haunting image of a time long ago when there were no worries about overcrowding. As the town braces itself to open its parks and beaches to the public for the first time, many residents fear that the fragile ecology of the beach areas may be overwhelmed by the influx.

This is a more typical beach scene, showing how extensive the sands become at low tide. Tod's Point is named for J. Kennedy Tod, and its 147 acres were once his private estate, complete with golf course. When the town bought the property after World War II, there was a great deal of dissension and controversy over the $550,000 purchase price. It was, of course, one of the best investments the town has ever made, both financially and in terms of the pleasure it has brought to residents over the years. The Queen Anne building at the center rear houses a seaside museum for children, sponsored by the Bruce Museum.

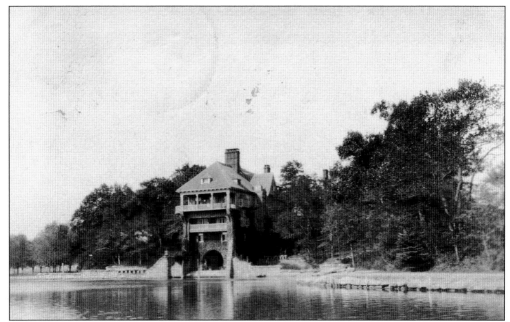

This 1908 view shows Tod's mansion, built *c.* 1887 and known as Innis Arden. Tod's widow left the estate to the New York-Presbyterian Hospital, and for a while this house was carved up into smaller apartments for returning servicemen after World War II. After the town bought the property, it was decided the mansion was too much of a liability and it was torn down in 1962. It its place today are beautiful gardens rising up the hillside.

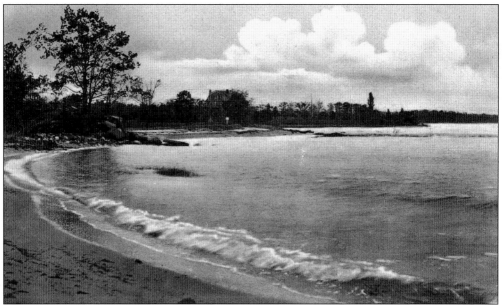

This image of Sandy Beach in 1906 shows the shorefront property that the town wanted to acquire in the Mead's Point area in 1918. At the time, Island Beach was up for sale but the town had already declined to buy it. The Mead's Point landowners convened in haste, and the Lauder family was elected to purchase the island for the town, thereby allowing this beach to remain in private hands.

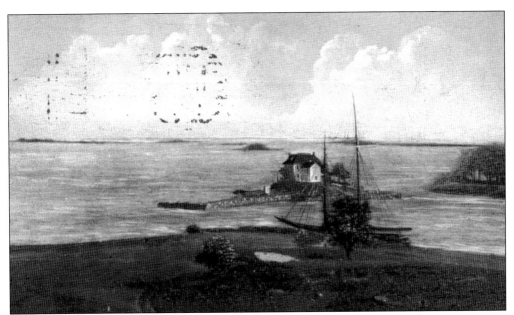

At the western end of town lies Byram Beach, bought from the Ritch family after World War I as a town park. In addition to the beach itself, the park has playing fields and the only town-owned swimming pool. Like the beach at Tod's Point, this area will also be open to the general public beginning in the summer of 2002. At the time this 1907 view was taken, the property was still privately owned.

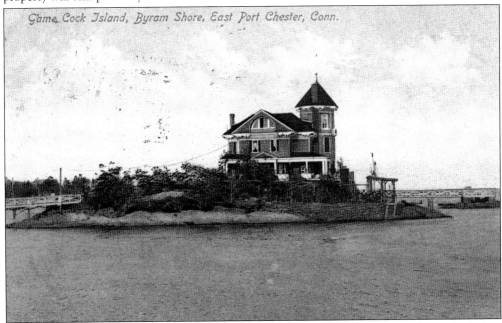

Many islands near the Greenwich coastline have had private homes on them, including Shell Island, Horse Island, Wee Captain's Island, Gaertner's Island, and Game Cock Island, which is shown in this 1908 view. Its name apparently comes from the fact that the fighting gamecocks, which provided entertainment to a segment of the town's population, were bred and raised here.

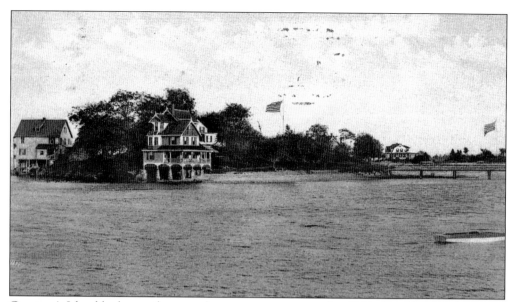

Gaertner's Island had room for several structures, as seen in this 1909 view. Flying the flag was as popular then as today, it seems. Undoubtedly life on these islands was pleasant indeed in the summer months; the winter season may have been another matter. However, this island was linked to the mainland by a causeway, so at least one did not have to travel by boat, as the lighthouse keeper did.

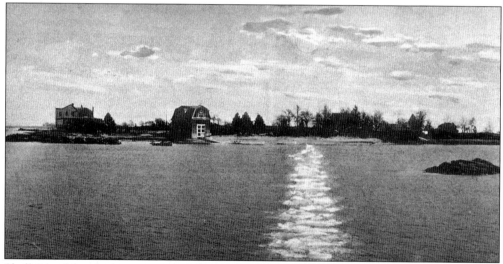

Shell Island has had an interesting history. After this image was taken around the time of World War I, the island was bought by a German who erected a large circular stone tower as his dwelling. Upon his death it was rumored that he had been in contact with the Nazi regime during World War II and had received military decorations for his services to the Germans. In 1990, the island, with its now-ruinous tower, was given to the Greenwich Land Trust as a wildlife preserve. Perhaps this is as fitting a time as any to pay tribute to the Land Trust and the wonderful job it has done over the years of helping to preserve the town's fast-dwindling open space. Greenwich has been enriched far beyond any monetary measure because of its efforts, which have helped to maintain the quality of life that is so vital to the present and the future of the town.

Nine
WHITHER GREENWICH?

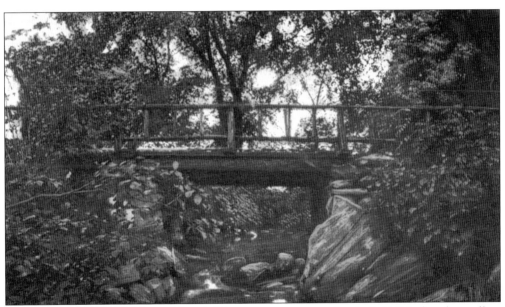

This rustic bridge of 1907 would probably not support one of today's SUVs, let alone allow two of them to pass each other on its wooden span. Like the other images presented in this book, it may well raise some questions in the mind of the reader, such as, where will continued overdevelopment and the incessant demand for more parking lead? What may be the effects of the recent (September 2001) Connecticut Supreme Court decision forcing Greenwich to open its formerly private beaches, islands, and parks to the general public? What are the possible consequences of the events of September 11 for the town? While there are obviously no hard and fast answers to these questions, the author hopes that the mere raising of them in conjunction with these pictures of bygone Greenwich will cause many people to take a much more serious look at where the town has been and where it is heading. These images may even serve as a primer for local town planning committees and, perhaps, be used in some local classrooms as well. We cannot turn back the clock and recover that part of the town's history that is lost forever; but we can look ahead and try to preserve what we still have.

GREENWICH
BUSINESS ADVERTISING DIRECTORY

Jas. H. Brush, Judge, res. Charmonte.
Gideon Close, Town Clerk.
L. P. Hubbard, Clerk of Borough, Main st.
Jas. H. Hoyt, Physician and Surgeon, Main st.
H. Peck, Principal Boarding School, Main st.
Wm. Elliott, Prop'r Elliott's Boarding House, cor. Main and Greenwich av.
Brush & Wright, Dealers in General Merchandise, cor. Main and Mechanic st.
Geo. Silleck, Merchant Tailor, corner Main and Greenwich av.
John Dayton, Dealer in Boots and Shoes, Greenwich av.
J. H. Merritt, Ice Cream Saloon, Dealer in Fruits, Vegetables, &c. Greenwich av.
Henry Held, Wholesale and Retail Dealer in Meats of all kinds, Greenwich av.
W. & R. Talbot, Manuf'rs Tin and Sheet Iron Ware and dealers in Stoves, Greenwich av
Peter Acker, dealer in General Merchandise, cor. Main and Greenwich av.
Jas. Mead, Undertaker, Lafayette Place.
Jos. Russell, Carriage and Wagon Maker.
Matthew Mead, Boot and Shoe Maker, Main st,
Jas G. Mead, dealer it Cut and Building Stone, Main st.

Erastus Burns, Carpenter, First av.
Col. T. A. Mead, resident Main st.
Thos. Mayo, " "
P. Button, " "
Wm. Tweed, " "
D. B. Breck, " "
Mark Banks, " "
H. M. Benedict, " "
R. Mead, " "
D. J. Stewart, " "
G. F. Ackerman, " "
R. Poillon, " "
Solomon Mead, " Maple av.
Alvan Mead, " "
C. E. Knapp, " 'Greenwich av.
S. M. Mead, " "
G. W. Hunt, " "
H. M. Bailey, " "
D. S. Mead, " "
W. R, Dunton, " Lafayette Place.
T. W. Mason, " cor. Main and Lafayette Place.
Brush Knapp, " Second av.

This listing of merchants in central Greenwich in 1867 gives one a good idea of what the local economy was like in those days. What would a similar listing look like today?

One of the major problems facing Greenwich is the sheer volume of traffic that passes through the town on a daily basis. Back when I-95 first opened some 50 years ago, it was a pleasure to cruise up and down the wide, empty lanes. It was even a pleasure to pay a toll for the privilege. Today, the story is far different. Choking traffic jams, speeding 18-wheelers jockeying in and out of traffic, and too little space for too many vehicles have created a daily scenario of accidents waiting to happen. And happen they do, sometimes with fatal results.

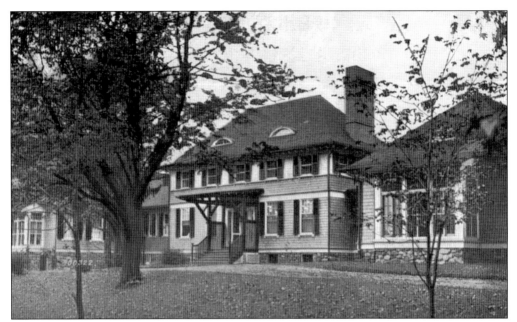

This was an early home of the Greenwich Hospital, seen here in 1908. The building was later occupied by the YWCA.

This late-19th-century trade card was typical of those passed out by local merchants. The 1867 directory on the opposite page shows a Merritt store on Greenwich Avenue.

One solution to this problem suggested by the images is this book might be, less is more. Our local streets and highways, as we have seen, go back in some instances to Colonial times and were clearly not designed to accommodate today's traffic conditions. Even by the 1930s, Greenwich Avenue was becoming clogged with motorcars.

There are no lanes like this one left anywhere in Greenwich today.

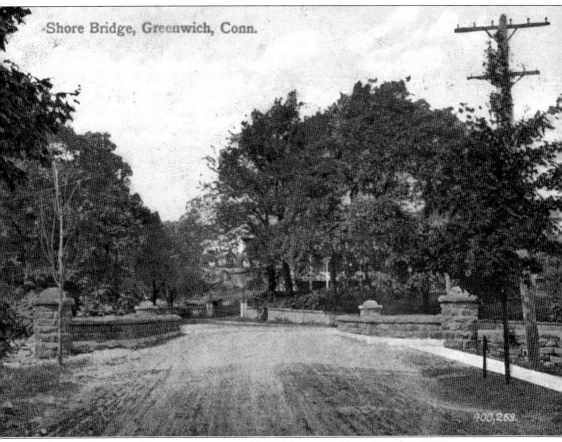

This dirt roadway was the main entrance to Belle Haven via Shore Road in 1907.

History teaches us that the past is prologue and that those who do not learn from its lessons are destined to repeat its mistakes. What lessons might the images in this book hold for us today?

The importance of mass transit is clearly one of them. The railroad first opened up Greenwich to the outside world, bringing in summer visitors and carrying Greenwich produce to the city. After 1907, train service in the greater New York metropolitan area was materially dependent on the Cos Cob power plant; if the plant went down, so, too, did the trains. The power plant is gone, but the trains are still here and offer the same opportunities for people- and product-moving that they did a century ago. Perhaps we rely too heavily on our cars and trucks and not enough on the railroad.

And then there is the trolley. In the early 20th century, one could ride the trolley all the way from New York to Boston. However, one town broke the link after World War I, tearing up its trolley tracks despite the strenuous protests of its neighbors all along the rest of the route. That town was Greenwich.

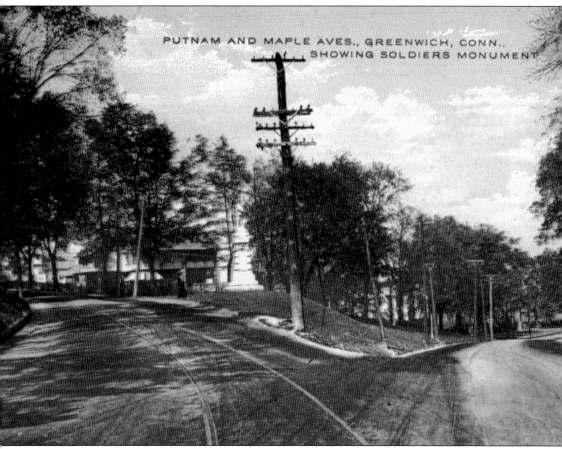

"Two roads diverged . . ." In 1909, one could ride the trolley up Maple Avenue or on towards Stamford via Putnam Avenue. In fact, one could ride the trolley all the way from Boston to New York and back if one chose. Today's traveler would probably prefer the Acela Express, with its 100-plus mile-per-hour speeds, but the view from yesterday's trolley would likely have been more interesting.

Perhaps it is time to reconsider. Take a look at downtown Greenwich now as opposed to the the images of 100 years ago. If one examines the present traffic situation—congested, to say the least—and compares it with the past, one can conclude that it will only get worse.

So, why not ban cars from Greenwich Avenue and make it a pedestrian mall? We have the space at the top, the bottom, and the sides to enlarge existing parking lots and garages. Modern-day nonpolluting electric trolleys could ramble up and down, allowing shoppers to hop on and off as often as they wished, the cost included in their parking fees. Is that a win-win situation or a mere pipe dream?

The reader may well have his or her own ideas, perhaps prompted by the pictures in this book. If these images of bygone Greenwich help to engender a greater appreciation of the past, as well as some thoughtful discussion of the future, then the work of compiling and presenting them will have been well worth the effort. It is with both of these hopes that the author offers this book to the public.

<div style="text-align: right">Greenwich, Connecticut
March 2002</div>